Rembrandt
as printmaker

Martin Royalton-Kisch

HAYWARD GALLERY TOURING
South Bank Centre, London

Published on the occasion of *Rembrandt as printmaker*,
a Hayward Gallery Touring / British Museum Partnership
UK exhibition

exhibition tour

8 April – 18 June 2006	Ferens Art Gallery, Hull
24 June – 3 September	Victoria Art Gallery, Bath
14 October – 31 December	Laing Art Gallery, Newcastle
28 April 2007 – 24 June	The Potteries Museum and Art Gallery, Stoke-on-Trent
30 June – 8 September	Grundy Art Gallery, Blackpool

Exhibition curated by Martin Royalton-Kisch
**Exhibition organised by Roger Malbert, Isabel Finch
and Henrike Ingenthron**

**THE
BRITISH
MUSEUM**

A Partnership UK project

Book design AlexanderBoxill
Art Publisher Caroline Wetherilt
Publishing Co-ordinator James Dalrymple
Sales Manager Deborah Power
Printed in Italy by Amilcare Pizzi / F&G Associates
Repro Icon

Front cover Rembrandt, *Self-portrait, etching at a window*,
1648 (cat. 34, detail)
Back cover Rembrandt, *The three crosses* , 1653 (cat. 46)

Published by Hayward Gallery Publishing
South Bank Centre
London SE1 8XX UK
www.hayward.org.uk
© Hayward Gallery 2006
Texts © the authors 2006

ISBN 1 85332 255 5

Hayward Gallery Publishing titles are distributed outside
North and South America by Cornerhouse Publications
70 Oxford Street
Manchester M1 5NH
t +44 (0)161 200 1503
f +44 (0)161 200 1504
e publications@cornerhouse.org
www.cornerhouse.org/publications

contents

04 **foreword**

06 **400 years of Rembrandt and his prints**

15 **plates**

86 **Rembrandt's prints** some technical terms

87 **chronology**

88 **catalogue**

foreword

Of all the traditional printmaking techniques, etching is the most intimate.
The soft wax into which the image is drawn or imprinted allows each subtle
inflection of the artist's hand to register as clearly as in a drawing in ink or
pencil. Rembrandt is one of very few great painters in the history of Western art
whose etchings are as famous as his paintings. These small monochrome prints
reveal the full grandeur and profundity of his vision. All the important subjects
of his paintings are represented in his etchings, including portraits, self-portraits,
character studies, vignettes from everyday life, biblical scenes and landscapes.
This book and the exhibition it accompanies present a selection of masterpieces
from every genre. They show the depth of Rembrandt's psychological insights,
his extraordinary powers of representation and his own thought processes as
revealed in the successive states of certain key prints.

The British Museum owns one of the world's finest collections of Rembrandt's
graphic works. In 2000 the Museum organised with the Rijksmuseum, Amsterdam,
a retrospective exhibition of his prints, accompanied by an authoritative catalogue.
The curator, Martin Royalton-Kisch, has selected more than 60 etchings for this
touring exhibition to celebrate the 400th anniversary of the artist's birth (an
occasion that is being marked by many exhibitions and events internationally).

Rembrandt as printmaker is the latest in a long series of successful collaborations
between the Hayward Gallery and the British Museum. It marks a new stage
in our relationship with the Museum, which has a wide-ranging network of
partnerships across the UK. The Hayward's touring programme complements
these initiatives; in most cases our links are with galleries and museums
dedicated largely to modern and contemporary art. The place of historical work
in this context depends on its present interpretation. The current revival of interest
in drawing, for example, coupled perhaps with a reaction against the seamless
perfection of technological imagery, might awaken an appreciation of the raw
truth of Rembrandt's realism – as seen in his acute depictions of beggars, dogs,
children, nudes and old people. Or a contemporary emphasis on the creative
process and the evolution of an image could lead to fresh insights into

Rembrandt's radical experimentation, apparent in his scoring out and recasting of figures from one state to the next (several examples are shown here). In any case, each new generation must discover the art of the past on its own terms, but to do so it must encounter it directly. This exhibition gives a succinct introduction to one of the greatest artists of all time.

Our thanks are due firstly to Martin Royalton-Kisch, who has shared generously his knowledge and insights in selecting the exhibition and writing all the introductory texts and commentaries on the works. Antony Griffiths, Keeper of the Department of Prints and Drawings at the British Museum, has, as always, been thoroughly supportive, as has Frances Carey, Head of National Programmes. Janice Reading, Loans Administrator in the Department of Prints and Drawings, has provided vital help at every stage. Thanks are also due to Mark McDonald, Curator of Old Master Prints, and Charlie Collinson.

At the Hayward, Helen Luckett has researched and compiled the contextual portfolio and reading area and given valuable advice along the way. Imogen Cornwall-Jones contributed useful research into the history of commentaries on Rembrandt by artists and writers through the centuries. Isabel Finch and Henrike Ingenthron have provided support on the organisation of the exhibition. Caroline Wetherilt and James Dalrymple have worked tirelessly and patiently on the catalogue, as has the designer, Violetta Boxill. Helen Faulkner and Alice Lobb have overseen the design and production of marketing and publicity material, and Eleanor Bryson has been responsible for press. Imogen Winter, the Hayward's Registrar, Alison Maun, Transport and Bookings Administrator, and Dave Bell, foreman, have co-ordinated the tour, transport and installation. We also thank our colleagues in the host galleries for their enthusiasm and commitment: Christine Brady at Ferens Art Gallery, Hull; Jon Benington at Victoria Art Gallery, Bath; Julie Milne at the Laing Art Gallery, Newcastle; Ian Vines at the Potteries Museum and Art Gallery, Stoke-on-Trent; and Stuart Tulloch at Grundy Art Gallery, Blackpool.

Roger Malbert Senior Curator, Hayward Gallery Touring
Susan May Acting Director, Hayward Gallery Touring

400 years of Rembrandt and his prints

Martin Royalton-Kisch

An appreciation of Rembrandt's art, including his prints, has never abated since his own lifetime (1606–69), and large numbers of people still admire, discuss and collect his works. His name is invoked in almost every kind of art-historical discussion, from the semiotic to the feminist, and postcards of his work are emblazoned on the studio walls of many a living artist. Enormous sums change hands for sheets of paper that were peeled away from his copper plates some three and a half centuries ago, let alone for his paintings and drawings, and exhibitions of his work occur regularly worldwide. In 2006, celebratory displays are taking place in at least eight countries, and some of the British Museum's Rembrandts are included in an exhibition of treasures that is touring Korea and China. The continuing spread of Rembrandt's fame is emblematic of the planet's gradual but inexorable move towards becoming a 'global village', in which people from widely different cultures will increasingly share interests in common, including, perhaps, an admiration for Rembrandt. This phenomenon is hopefully a force for the good.

From a modern perspective, it can be difficult to empathise with the period in which Rembrandt himself established his fame and created his prints, paintings and drawings. Yet historians have begun to reconstruct how these works were marketed and circulated in the seventeenth century. One of Rembrandt's paintings, a self-portrait (probably the one now in the Walker Art Gallery in Liverpool), is recorded in Charles I's collection in 1639 and may have been there as early as 1633, an extraordinary achievement for a 27-year-old Dutch artist. Where the prints are concerned, some indications of their circulation are provided by documents, as also by annotations of prices and names written on the backs of the prints themselves. It is known, for example, that Rembrandt's prints reached several European countries – Germany, France, Great Britain and Italy – in his own lifetime; and that his masterpiece as a printmaker, the so-called *Hundred guilder print* (cat. 36, p. 57), really did change hands for this enormous sum by 1654, six years after it was made.

Indeed, the main vehicle for spreading an artist's reputation in the seventeenth century was not generally his paintings, which could only be seen *in situ*, but his or her prints: images on paper printed from copper

plates that had been engraved or etched with lines. Printed editions were not large by modern standards – one thousand would have been a considerable edition for a print, even for one intended for wide distribution, because the copper plate would by then show considerable signs of wear. On publication the prints could be circulated freely, sold in shops, at fairs or in market squares, pinned up in public places, such as taverns and town halls, or studied and enjoyed by artists in their studios or by collectors at home with their friends.

If a print proved popular its success would fuel the demand for more of the same kind, enabling the investment necessary to prepare, make and distribute a new image. The production process required a considerable input of time, labour and materials. Not only was there the contribution of one or more artists (the designer and sometimes also the printmaker, although Rembrandt usually fulfilled both functions himself), but there was also the involvement of the printers and their presses, the cost of the copper plate, inks and paper and, once an edition had been run off, there was the business of distributing, stocking and selling the prints, whether locally, nationally or internationally.

Most of the great painters before Rembrandt – Raphael (1483–1520), Titian (c.1490–1576) and Rubens (1577–1640), for example – had limited their involvement with printmaking to the provision of the designs, whether in the form of paintings, drawings or oil-sketches. These were then handed to professional printmakers who produced engravings that copied or reproduced the prototypes. Rubens, who was one of Rembrandt's most immediate models as an artist, had been especially active in overseeing the creation of engravings that were based on his paintings. But unlike Rembrandt, who began to make his own prints from the time he was around 20 years old, Rubens only began to exploit the print market in earnest from 1609, by which time he was in his thirties. Closer precursors for Rembrandt's approach are to be found in two major figures who were born more than 100 years before him, Albrecht Dürer (1471–1528) and Lucas van Leyden (c.1494–1533). Both plied the trade of printmaking energetically and produced engravings of unequalled skill. Nearer to Rembrandt's own time, Hendrick Goltzius (1558–1617) devoted his talents entirely to printmaking and drawing for the greater part of his

career, and achieved widespread fame and recognition – not least for his skilful emulation of the styles of Dürer and Lucas. These artists all remained celebrated in Rembrandt's day and like Rembrandt had begun to make prints early in their careers. But whereas they had concentrated on making engravings, Rembrandt focused on etching, a technique that can give the artist the flexibility to draw on a copper plate as freely as with a pen.

In this choice Rembrandt was doubtless influenced by a trend that had been initiated around the time he was born, when Dutch artists such as Esaias van de Velde (1587–1630) and Hercules Segers (1589/90 – c.1635) refreshed the possibilities of etching through a combination of skill, vision and experiment. The young Rembrandt, as well as making his own etchings, also apparently employed other printmakers to make engravings after his designs. For example, a fellow artist from Leiden, Johannes van Vliet, made more than a dozen prints after prototypes by Rembrandt between around 1631 and 1634, some of them reminiscent of the prints being made for Rubens (see, for example, cat. 13 and 14, pp. 32 and 33). But as a rule, while many painters still relied on the skills of professional engravers to publish their designs, Rembrandt gave priority to producing his own, autograph etchings. This was despite the fact that the first results he achieved as an etcher were rather unprepossessing. For instance, the quality of the drawing in *The rest on the flight into Egypt* (c.1626, cat. 1, p. 16) seems slack and the contrasts of light ill-judged, and a less determined artist might have abandoned the technique at this early stage. But by the time Rembrandt made the exquisite etching of his mother's head in 1628 (*The artist's mother: head only*, cat. 2, p. 17), he had clearly mastered most of the technical skills required, although even here something must have gone wrong to make him cut the plate so uncomfortably close to his mother's chin. The image is a near-miraculous rendition of an old and vulnerable face, long besieged by the vagaries of life.

Yet not every print produced thereafter was an unmitigated success. On the technical front, for instance, it is clear that *Peter and John at the gate of the temple* (cat. 3, p. 18) of around 1629 suffered some sort of accident that resulted in strange bands of shadow disfiguring the image. Similarly

The artist drawing from the model of around 1639 (cat. 21, p. 42) and
St Jerome reading in an Italian landscape of around 1653 (cat. 45, p. 69) were
left unfinished, perhaps more for technical than aesthetic reasons. These
were not the only occasions when Rembrandt seems to have risked all
when pushing the limits of the possibilities of his medium. Nevertheless,
the overwhelming impression gained from a chronological overview of
Rembrandt's prints (as they are arranged in this book) is of a tirelessly
creative and experimental artist, sometimes attempting to reproduce
the informality of a drawn sketch (for example, cat. 3 and 28, pp. 18
and 49), sometimes working up his copper plates to an astonishingly high
degree of detail (cat. 12 and 33, pp. 30–31 and 54). But whether his touch
is that of the quick note-taker or the painstaking miniaturist, the most
enduring qualities of Rembrandt's art lie in his expressive powers of
representation: in the strength of his human characterisations, in his
telling of drama with its human pathos and in his convincing and poetic
descriptions of space, light and atmosphere.

No aspect of Rembrandt's art has fascinated commentators more than
his portrayal of human character, and nowhere is this facet of his art better
represented than in his etchings. For instance, *Self-portrait, open-mouthed,*
of 1630 (cat. 5, p. 20) is a work of pure alchemy. The size of a fridge
magnet, it consists entirely of 'a little ink placed here and there on a piece
of paper', to borrow the words applied to prints by the philosopher René
Descartes, who was living in Holland at the time. He was trying to explain
that appearances are not what they seem in his celebrated treatise, the
Discours sur la méthode, published in 1637. This is the book in which
Descartes famously declared *'je pense, donc je suis'* ('I think, therefore I
am'); but one is tempted to suggest that Rembrandt's print undermines
his famous thesis: the personality presented here seems to 'exist', even
to the point of thinking, yet it is merely a collection of ink molecules on a
page. This achievement is not merely technical, although certainly we may
admire the flickering and varied touch of Rembrandt's hand on the copper
plate: the tangle of lines for the hair, which admit just enough light – a
little more on the right, where light catches the hair directly; the tautened
muscles on the forehead, the anguished frown creating deep furrows above
the nose; the tense yet liquid left eye, surrounded by the white spaces of
this side of the face, and the sharply contrasting shadows on the left side,

which are, however, not wholly dark, with some reflected light in the cheek and a pinpoint flash on the eyelid; the way the ear is suggested, its lobe luminous while the rest is apparent only through a few curled tresses; the extraordinary and elastic opening of the mouth, black as pitch within, the bright teeth rendered individually in lines of less than half a millimetre; the light-struck lips in their pained grimace, with a few wisps of an incipient moustache above; the tautened, wrinkled nose, creased by two horizontal lines across the bridge that are scratched onto the plate with breathtaking delicacy. These details of the head are framed by the more casual drawing of the clothes, which contextualise the head perfectly without detracting from it. The spatial arrangement is keyed by the patch of shadow to the left, which contains echoes of the unkempt hairline. All in all the result conveys a palpable and immediate sense of reality, of the 24-year-old Rembrandt with the tousled and unkempt appearance of many a modern-day student. There can be little doubt that he drew this image directly onto the copper plate from his face in the mirror, studying a particular expression, one that could perhaps be of use in other works. Above all it is clear that this is a small miracle of skill in the quality both of the draughtsmanship and of the controlling mind. If the works of Rembrandt's own pupils are compared, it becomes obvious that despite receiving lessons from the master himself, they rarely approach such refinement. It is as if the copper simply would not 'perform' for them in the same way, even though their prints consist of precisely the same elements: 'a little ink placed here and there on a piece of paper'.

In thus attempting to analyse why this small image is still held in such high regard as a work of art, one is limited to such emotive descriptions and to comparisons with other works, whether or not by Rembrandt. One can also try to employ psychology or speculation: psychology because of the way Rembrandt evokes the convincing image of an individual personality, which invites projections into it about its age, character and state of mind; speculation because it is unclear why Rembrandt made this etching. Yet one feels compelled to respond to the many unsolved questions it begs. If this is a study of a particular expression, for a particular purpose, why did Rembrandt produce an etching, which had to be printed, rather than a drawing? Was the

expression intended to convey mental anguish, physical pain, or something else? Why did he use his own face for such an image? Why is it so small? How realistic is it? How long did it take him to make it? Was it widely circulated? Did he give impressions of it to his friends, or did he sell them? What was the reaction engendered by such an image when it was produced? What does it say about the image, and about modern spectators, that such questions remain a preoccupation so very long after it was made?

It is a great problem for the writer on Rembrandt, and perhaps especially on his self-portraits, that they engender such speculations. They are unanswerable, and only one factual response can be given to any of the questions above: that a similar face appears in the *Beggar seated on a bank* of the same year (cat. 4, p. 19). One cannot be sure, but perhaps the self-portrait came first. It is also known that Rembrandt's pupil, Samuel van Hoogstraten (1627–78), later advised young artists in his treatise of 1678, the *Inleyding tot de Hooge Schoole der Schilderkonst*, that 'you will also find the same assistance in expressing passions by using what you have before you, chiefly by being at the same time actor and spectator in front of the mirror.' For the rest, one can only be highly speculative. Yet it must be the ability of Rembrandt's images, generation after generation and even on such a small scale, to inspire empathy that makes them such great works of art. When faced with a composition of the complexity and sustained inventiveness of *The hundred guilder print* (c.1648, cat. 36, p. 57) the effect is overwhelming, as the characterisation of each face, each pose, each interaction, each movement and each gesture commands attention. From the doctors of the church engaged in disputes on the left, via the pensive young man half covering his face with his hand who is seated near them, through the commanding and ethereal figure of Christ in the centre, to the frail and exhausted figures of the sick approaching him from the right, a panorama of human qualities and conditions of mind and body is displayed. The dust-laden atmosphere, its light gathered, reflected, refracted and dissipated, unites this spectrum of humanity as it hovers around the unworldly figure of Jesus, the son of their god. Under Rembrandt's spell the viewer, too, is faced by the miraculous.

Even the landscapes, such as *The three trees* (1643, cat. 27, p. 48) and *Six's bridge* (1645, cat. 28, p. 49), where the human presence plays only a subsidiary role, captivate the spectator. *The three trees*, starkly silhouetted against a clear patch of sky, evokes reminiscences of the three crosses at the crucifixion of Christ. Yet life continues undisturbed: the fisherman on the left and his female companion, the lovers obscured in the undergrowth at the lower right, the diminutive cattle-farmer in the field with a group of figures at a similar distance towards the centre; the wagon on the dyke behind the trees, followed by a man on foot with a long stick, near where an artist is seated, sketching and looking out beyond the edge of the print – none of these figures responds to the gigantic meteorological drama unfolding around them: the streaks of sunlight, the rising vapours above the horizon, the shifting clouds traversing the windblown sky. The details of the bird launching itself from the trees and the distant flock far up above heighten the all-suffusing poetic mood.

It can be no wonder that images like these have served to sustain Rembrandt's reputation through the centuries, astonishing people now just as they must have done when the prints first rolled off the press. If the purpose of the visual arts is to inspire our admiration while increasing our understanding of the human condition, then perhaps no other artist has succeeded in touching people more deeply and more often since the seventeenth century. Whether among the later old masters, early modernists or contemporary artists, there is scant evidence of serious challengers. Goya? Van Gogh? Picasso? However many names one might wish to add, after 400 years the harvest is meagre, and Rembrandt seems set to preoccupy us for a long time to come.

further reading

Erik Hinterding, Ger Luijten, Martin Royalton-Kisch, *Rembrandt the Printmaker*, British Museum Press, London, 2000 (reprinted 2001). Christopher White, *Rembrandt as an Etcher*. Yale University Press, New Haven and London, 1999.
For further information see:
http://www.thebritishmuseum.ac.uk/pd/factsheets/rembrandt.html

plates

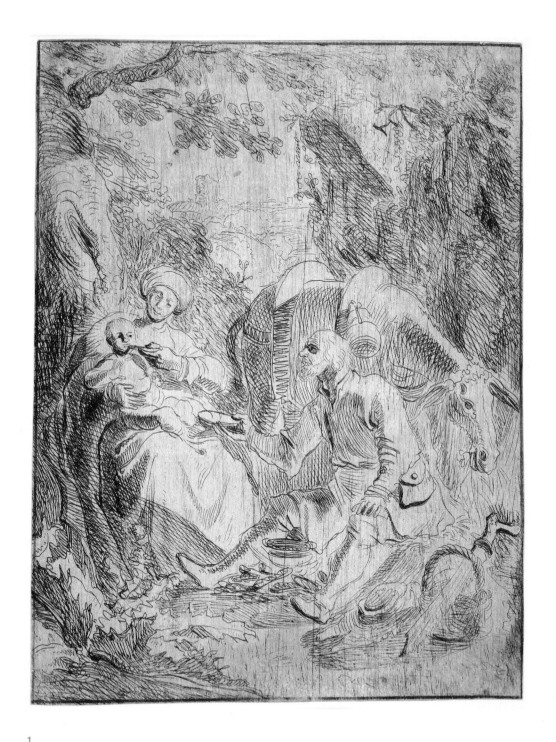

16 1

The rest on the flight into Egypt, *c.*1626

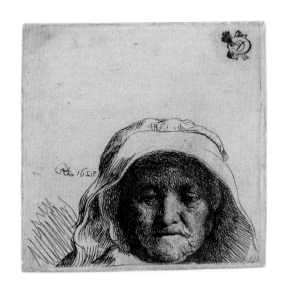

2 a
The artist's mother: head only, 1628
second state

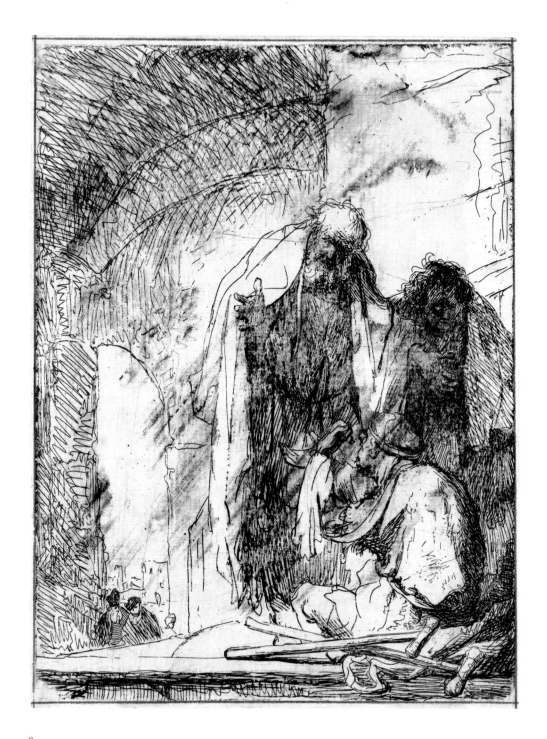

18 3
Peter and John at the gate of the temple, *c.*1629

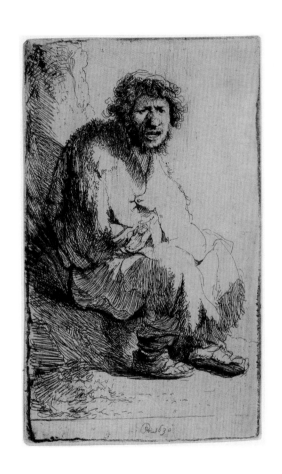

4 a
Beggar seated on a bank, 1630
only state

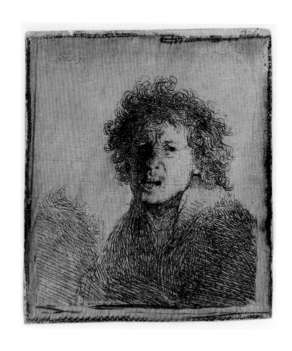

5 a
Self-portrait, open-mouthed, 1630
first state

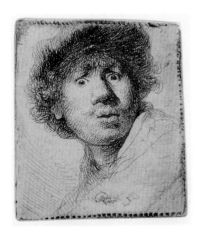

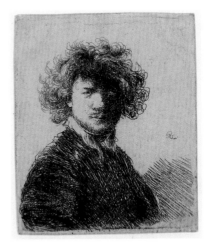

6
Self-portrait with beret, wide-eyed, 1630

7
Self-portrait with curly hair, c.1630

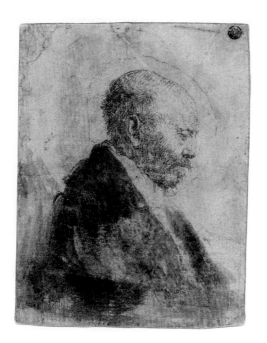 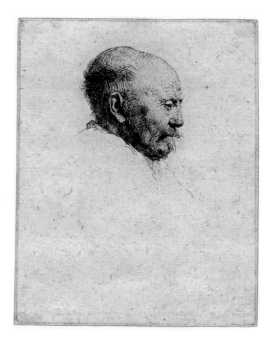

22 8 a–d
Bald-headed man in profile; the artist's father?, 1630
preliminary state with additions in brush and grey ink; first state;
second state; third state

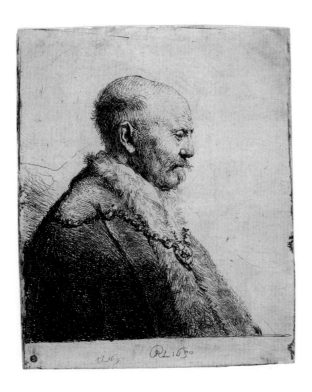

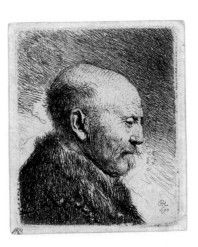

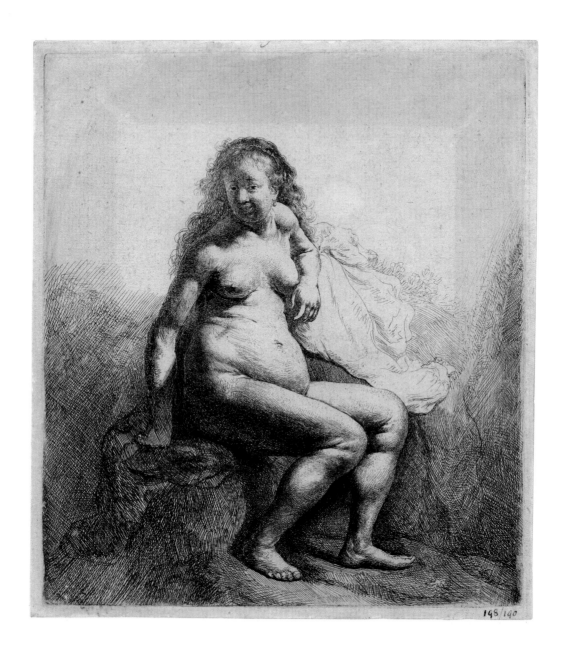

9
Naked woman seated on a mound, *c.*1631

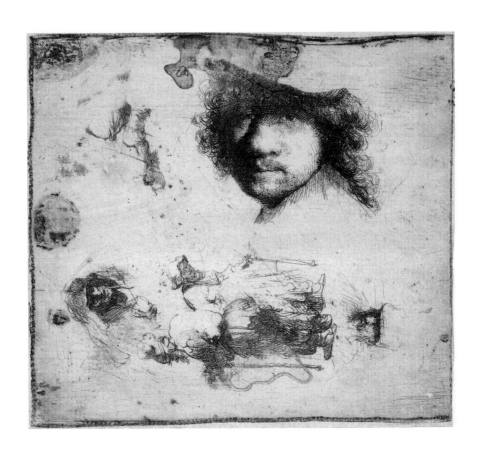

10 a–b
Sheet of studies, *c.*1631–32
first state; second state

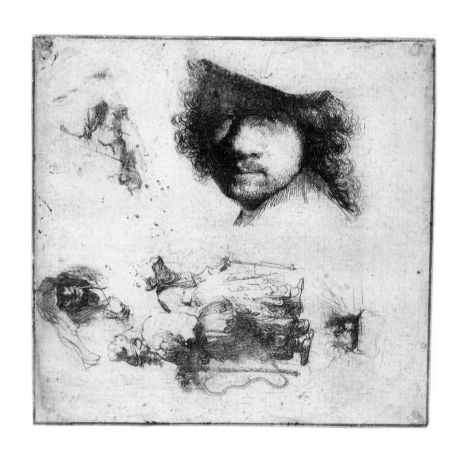

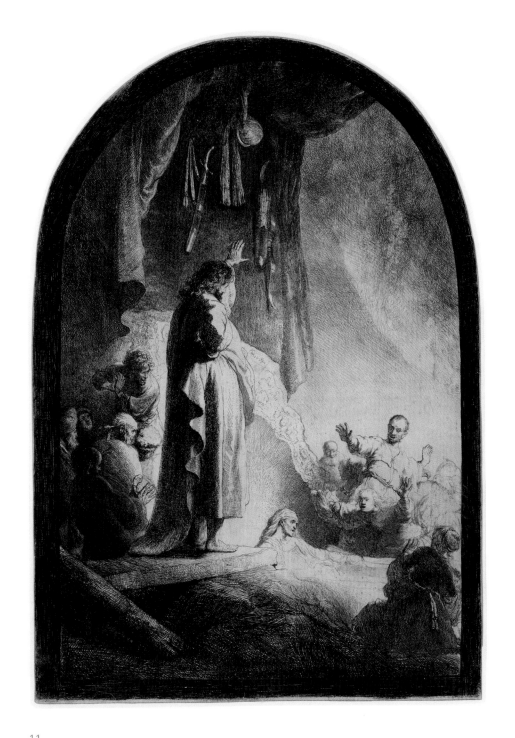

The raising of Lazarus: larger plate, c.1632

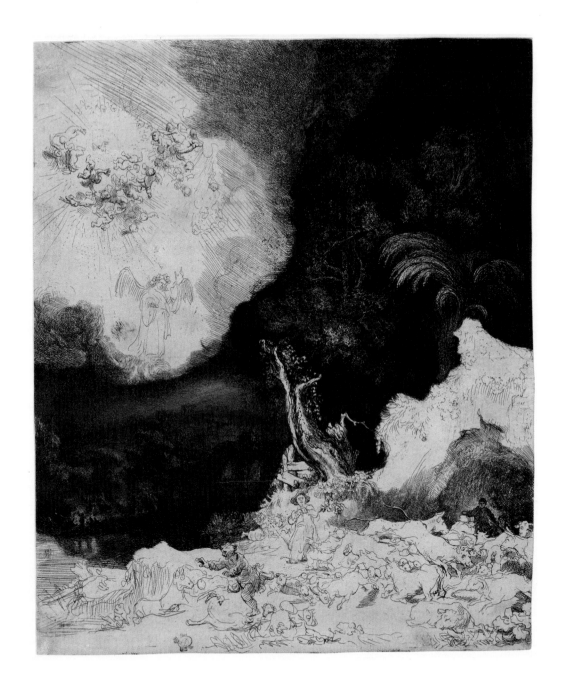

30 12 a–b
The angel appearing to the shepherds, 1634
first state, with touches of brownish wash; third state

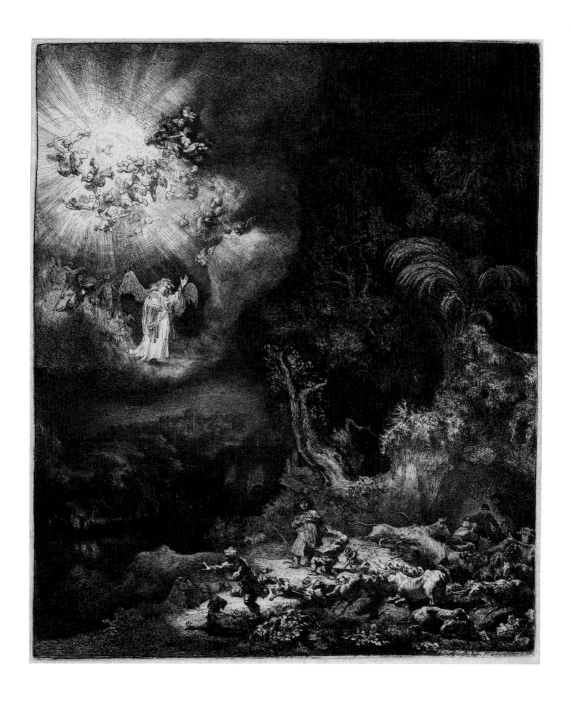

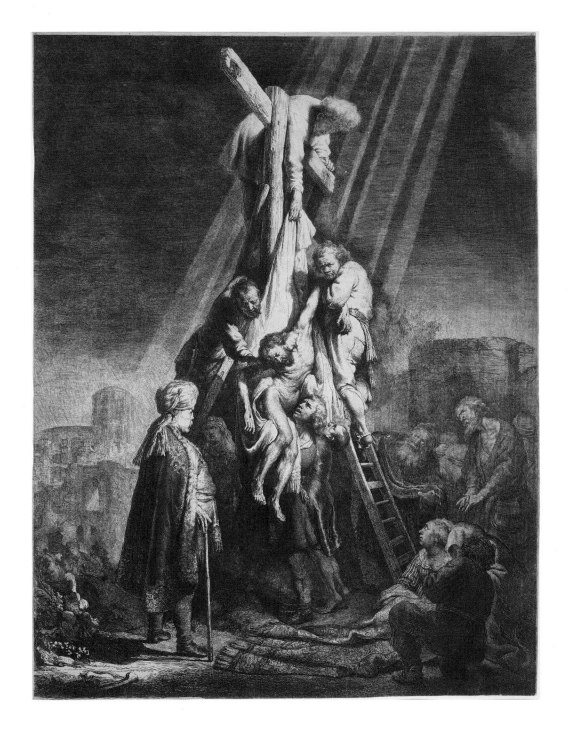

32 13
Johannes van Vliet after Rembrandt
The descent from the cross (second plate), 1633

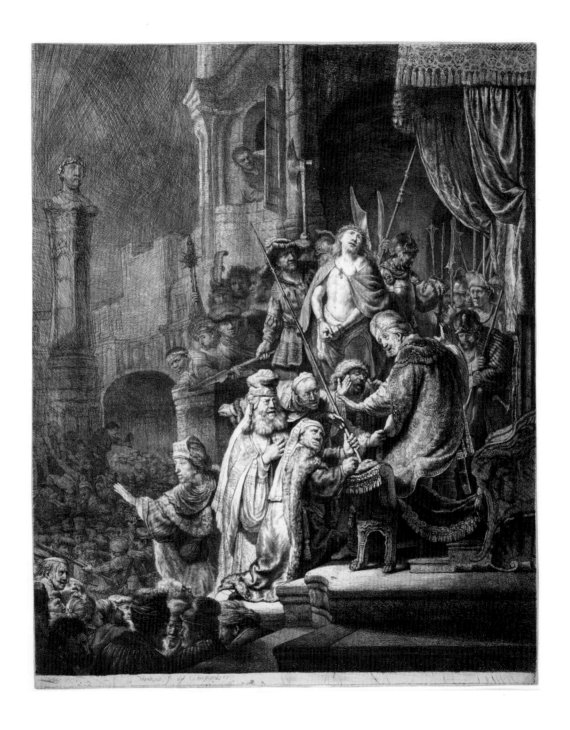

14
Johannes van Vliet after Rembrandt
Christ before Pilate: larger plate, 1635–36

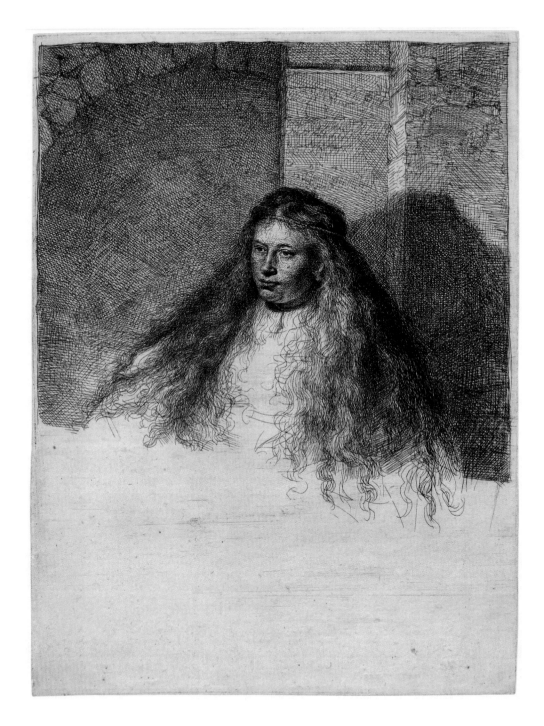

34 **15 a–b**
The great Jewish bride, 1635
second state; fifth state

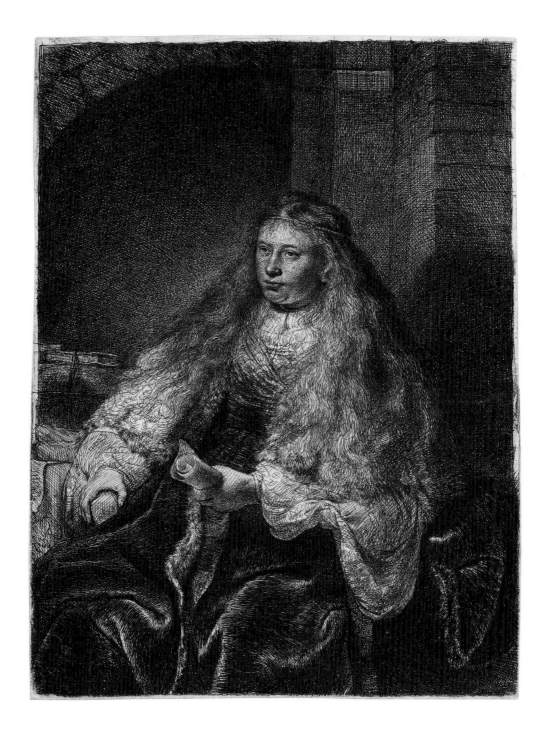

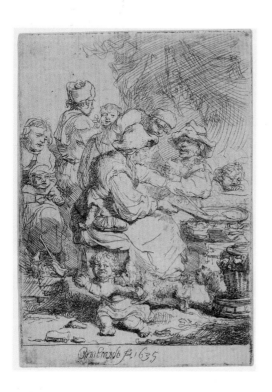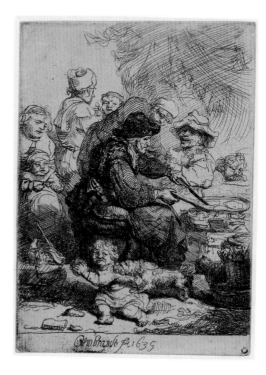

16 a–b
The pancake woman, 1635
first state; second state

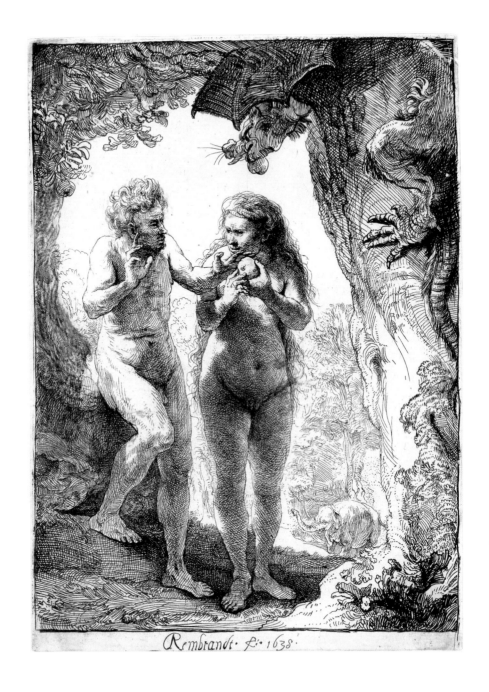

17
Adam and Eve, 1638

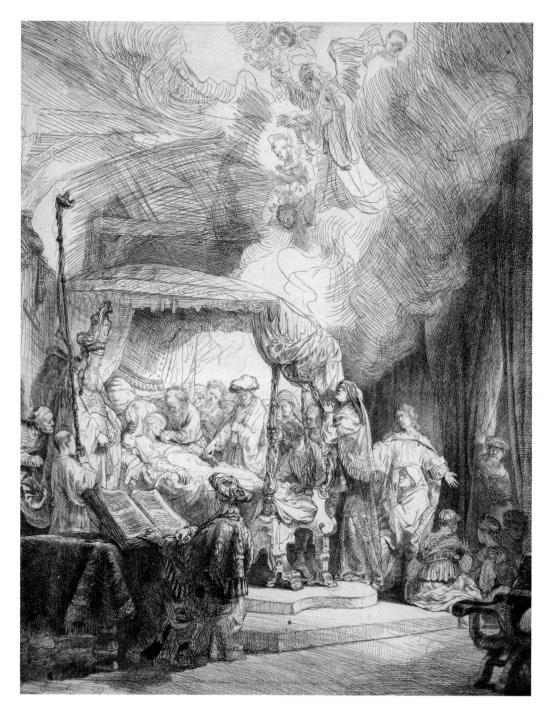

18
The death of the Virgin, 1639

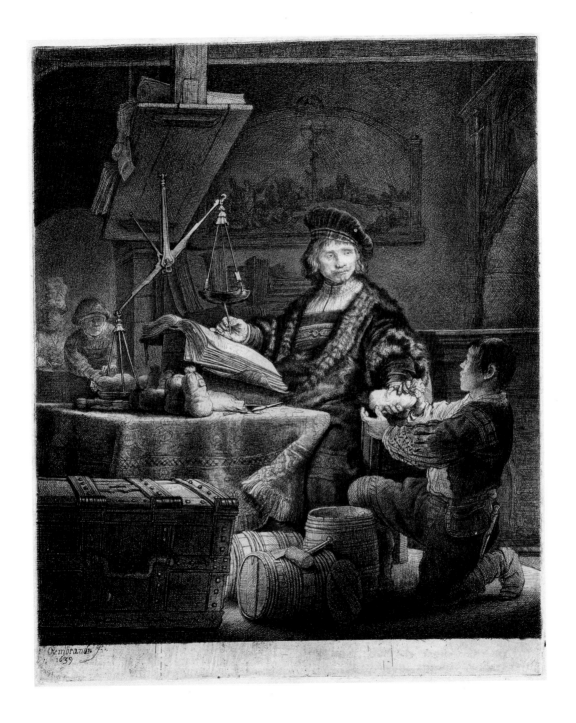

19
Jan Uytenbogaert, 'The Goldweigher', 1639

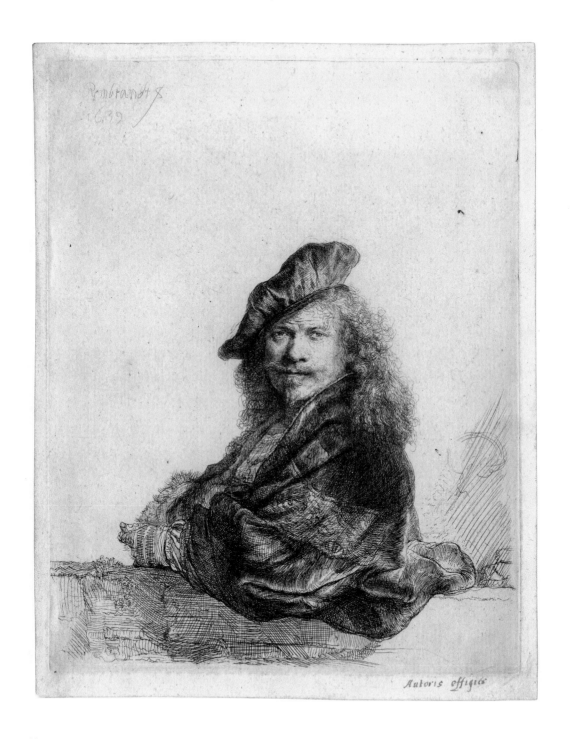

20 a
Self-portrait leaning on a stone sill, 1639
second state

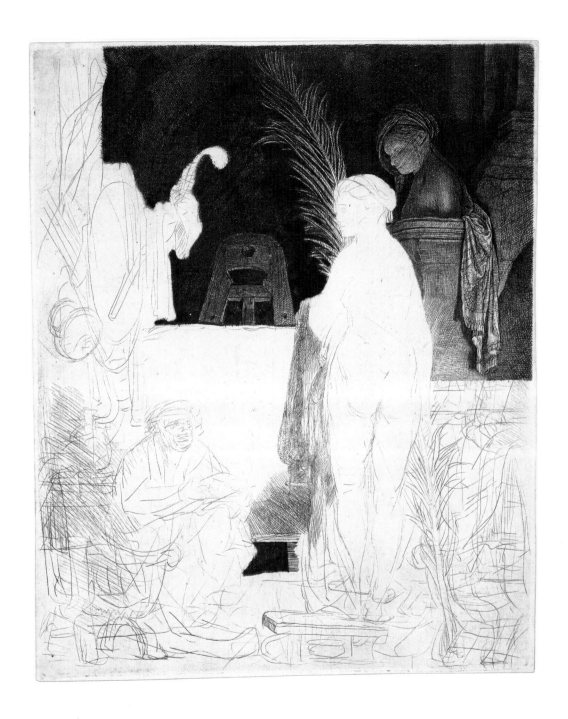

21
The artist drawing from the model, *c.*1639

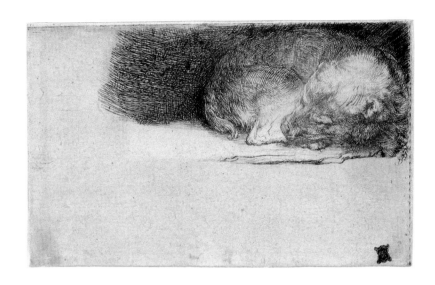

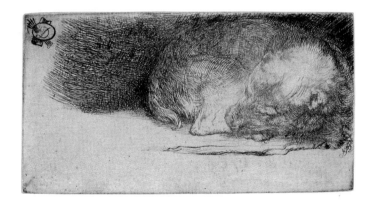

22 a–b
Sleeping dog, *c.*1640
first state; second state

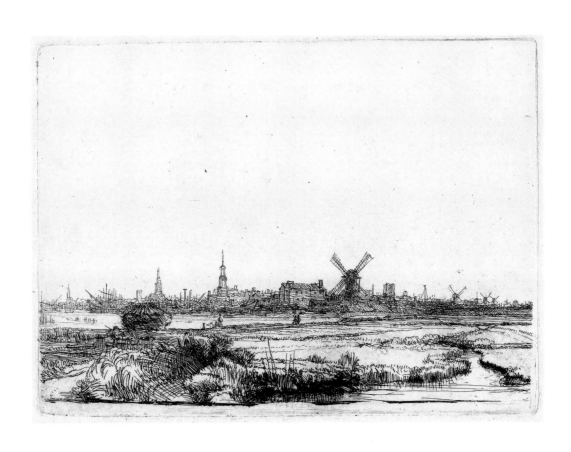

44 23
View of Amsterdam, *c.*1641

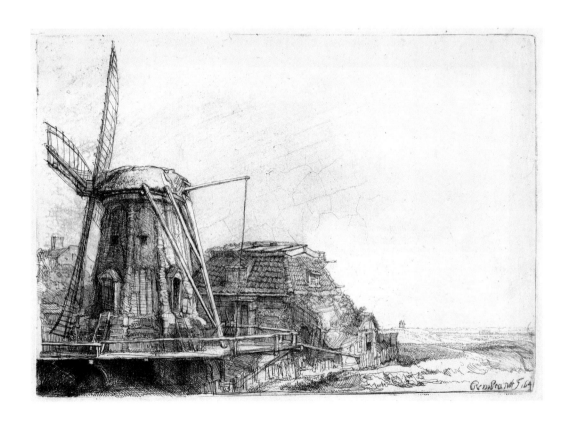

24
The windmill, 1641

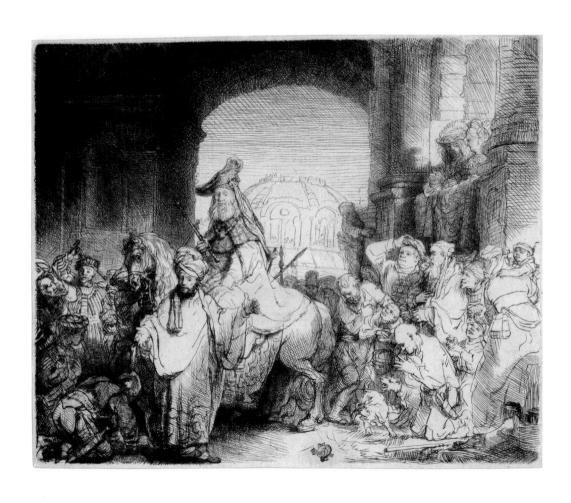

46 25
The triumph of Mordecai, *c*.1641

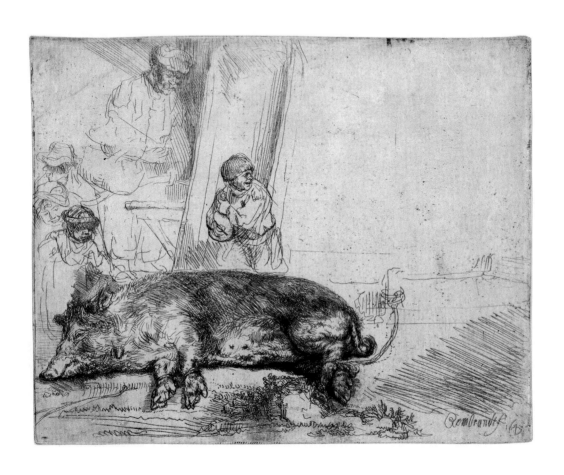

26
The sow, 1643

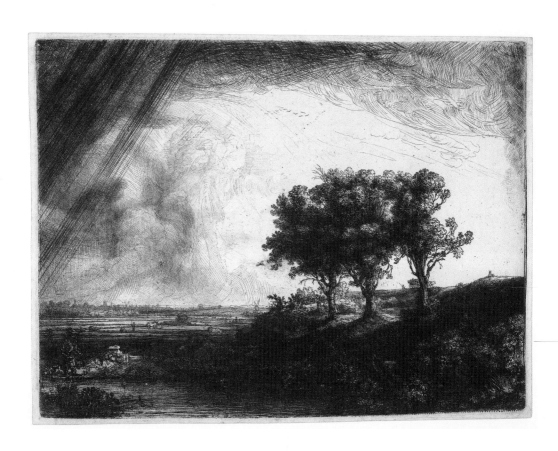

27
The three trees, 1643

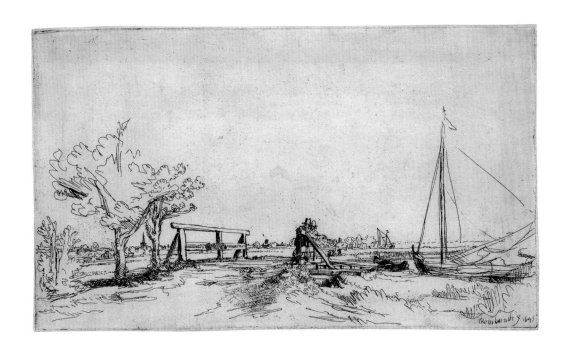

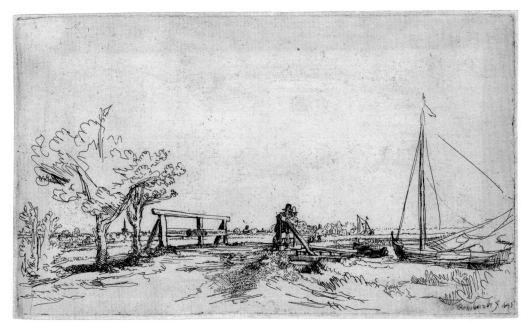

28 a–b
Six's bridge, 1645
first state; second state

29
The monk in the cornfield, c.1646

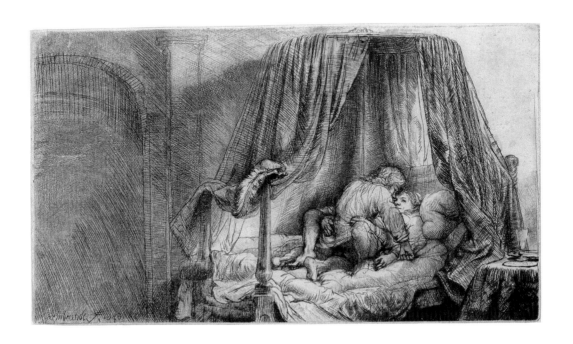

30
The French bed, 1646

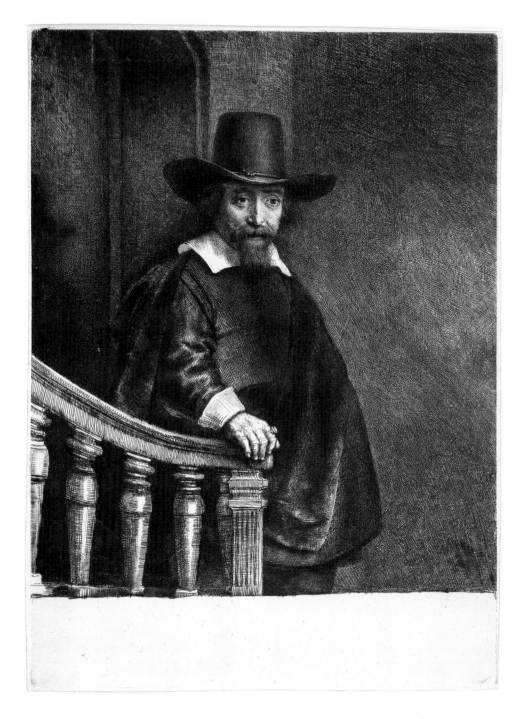

52 31
Ephraïm Bueno, physician, 1647

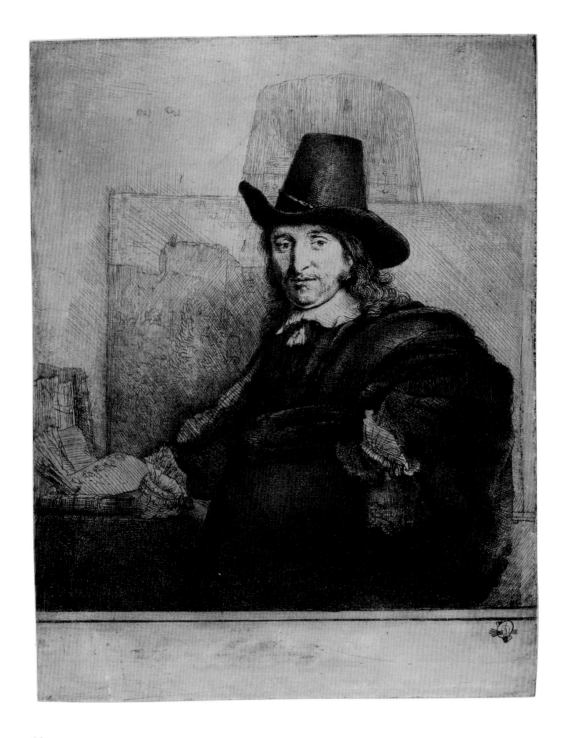

32
Jan Asselijn, painter, c.1647

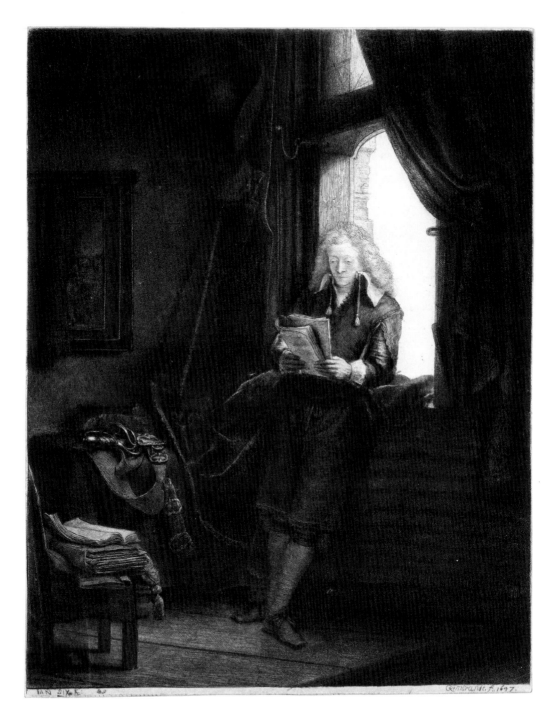

54 33
Jan Six, 1647

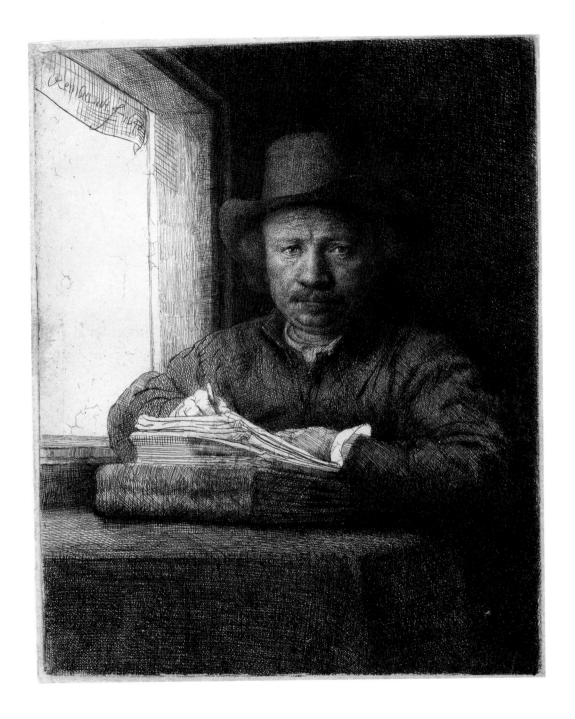

34
Self-portrait, etching at a window, 1648

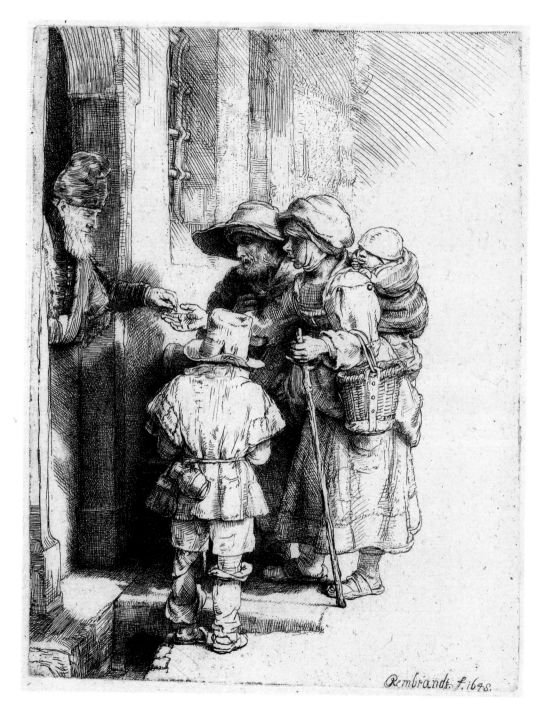

56 35
Beggars receiving alms at the door, 1648

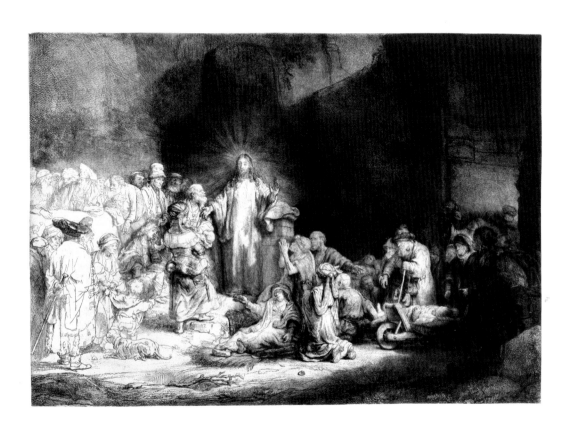

57

36
Christ healing the sick: the hundred guilder print, *c.1648*

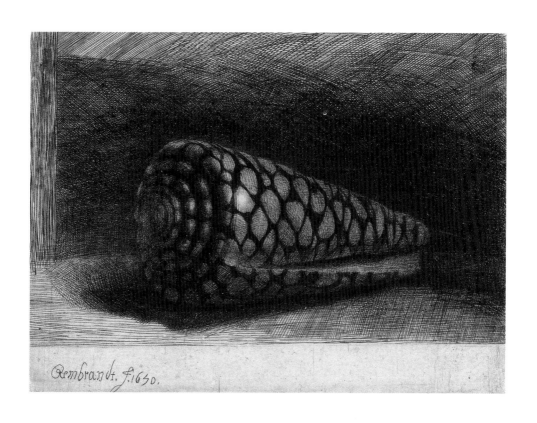

37
The shell (Conus marmoreus), 1650

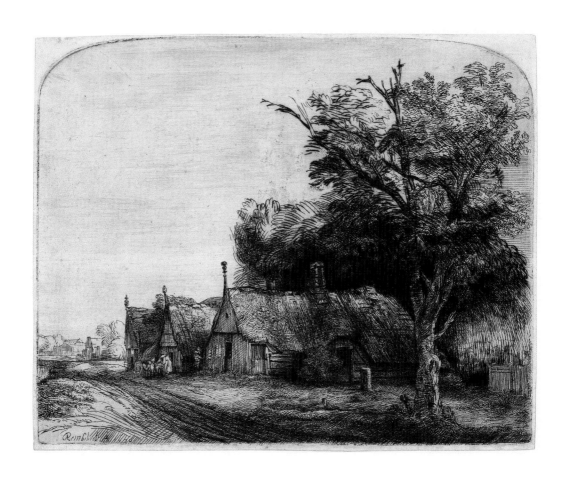

60 38 a–b
Landscape with three gabled cottages, 1650
third state; counterproof of third state

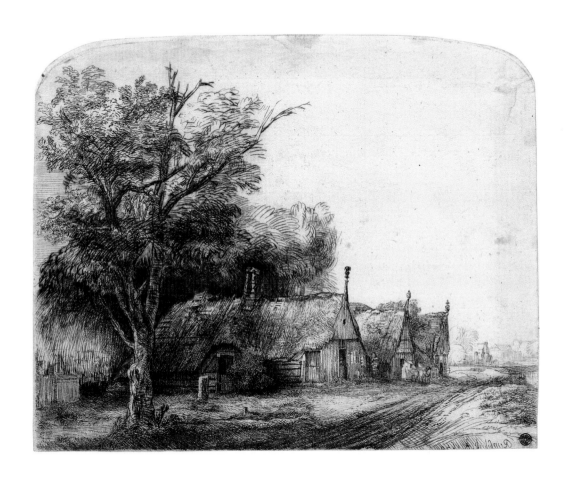

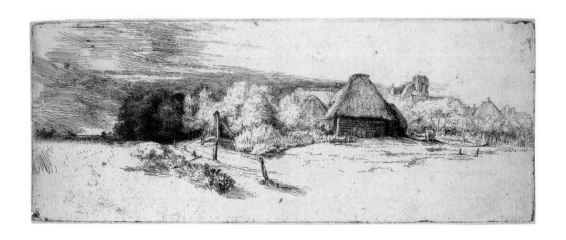

62 39
Landscape with trees, farm and buildings and a tower, *c.*1651

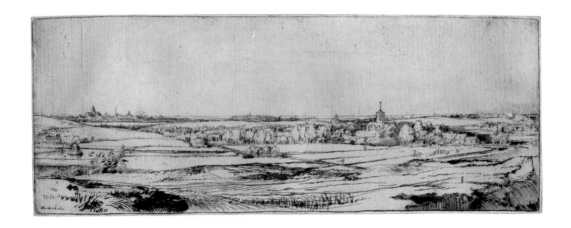

40
The goldweigher's field, 1651

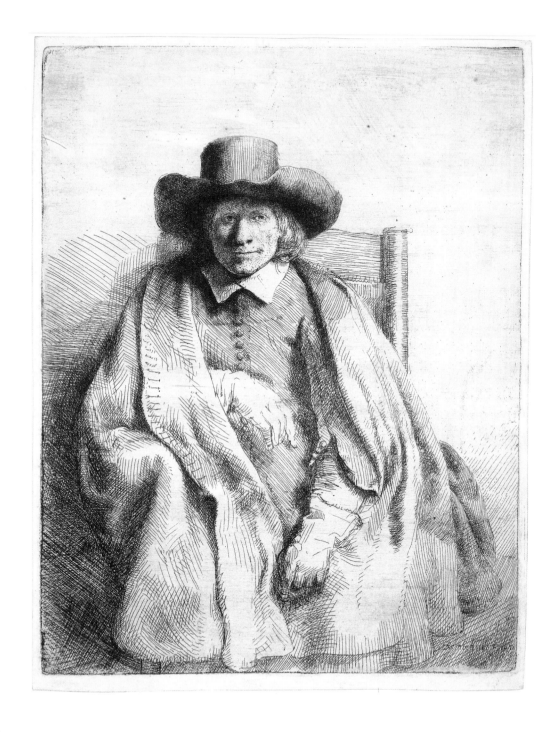

41
Clement de Jonghe, 1651

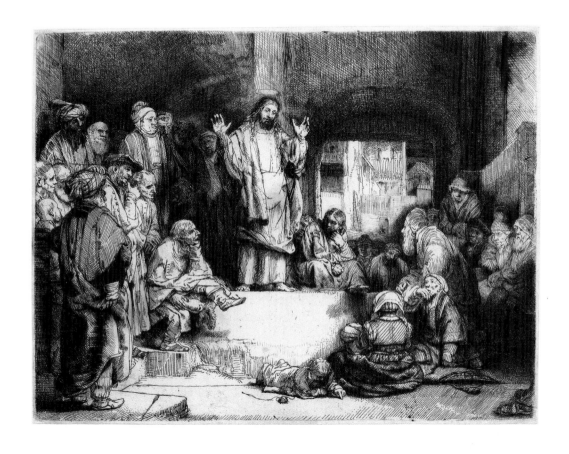

42
Christ preaching ('la petite tombe'), *c.1652*

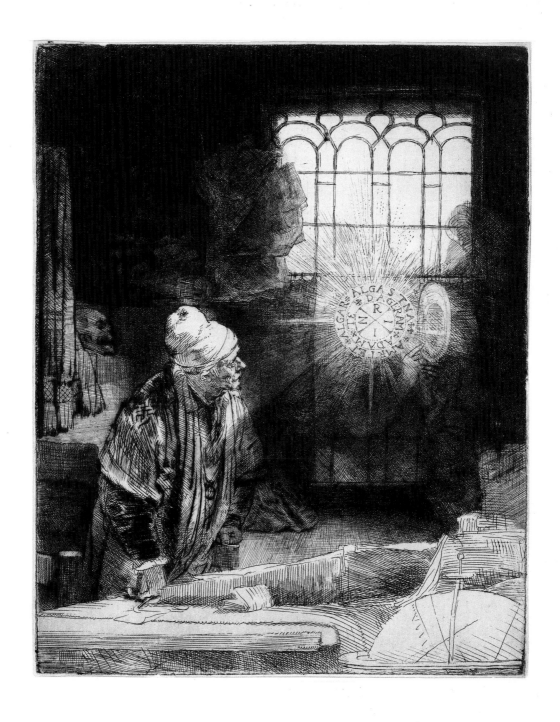

66　　43
A scholar in his study ('Faust'), *c.*1652

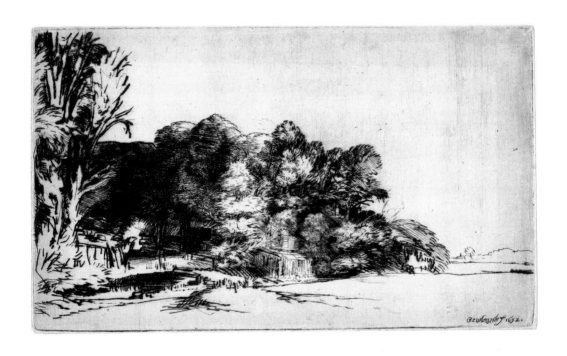

44
A clump of trees with a vista, 1652

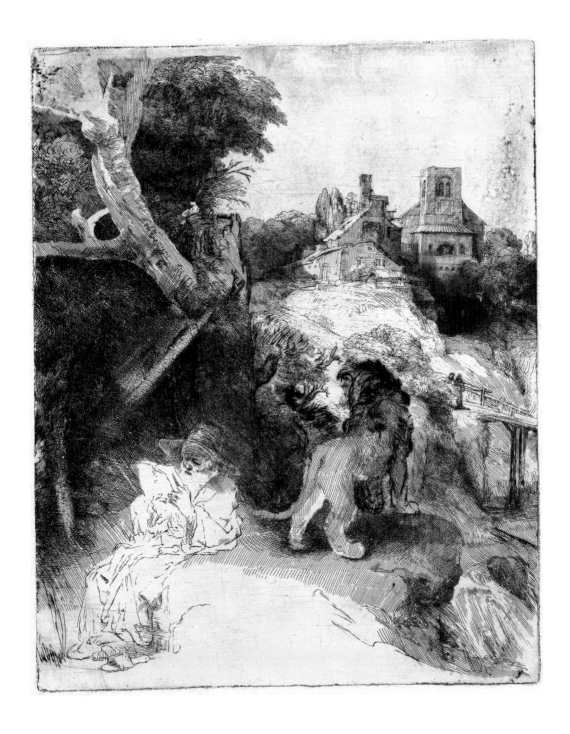

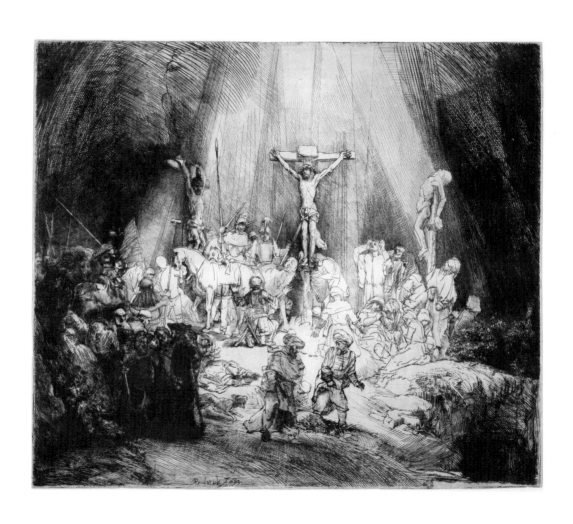

70 46 a–b
The three crosses, 1653
third state; fourth state

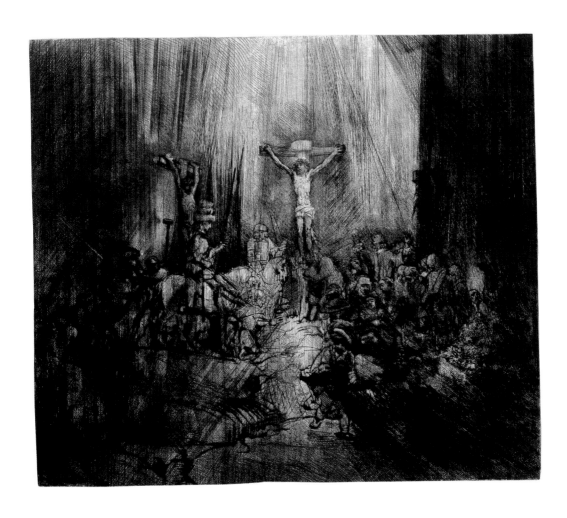

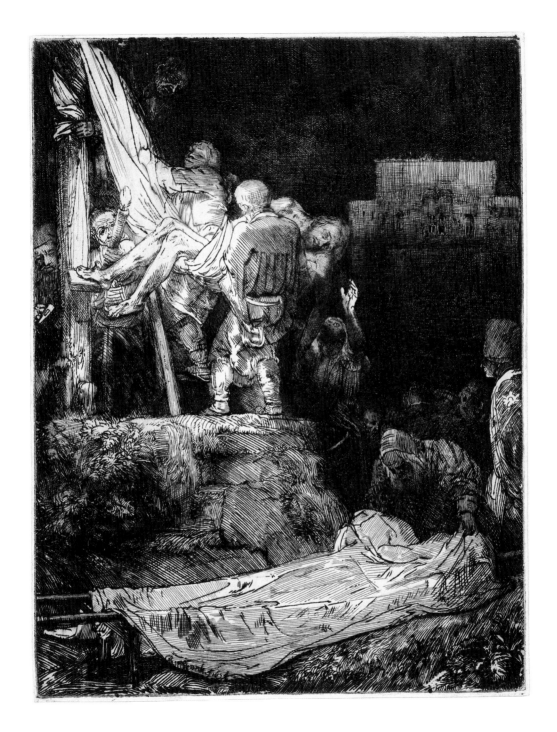

47
The descent from the cross by torchlight, 1654

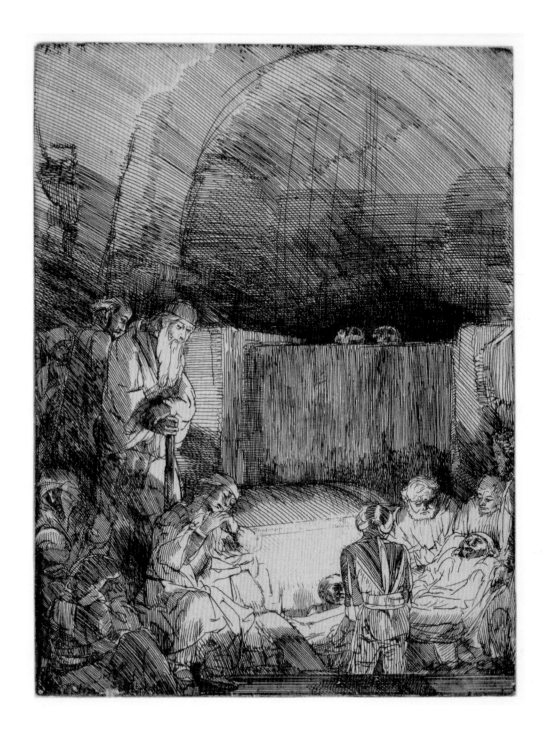

74 48 a–b
The entombment, *c.*1654
first state, on Japanese paper; second state, on Japanese paper

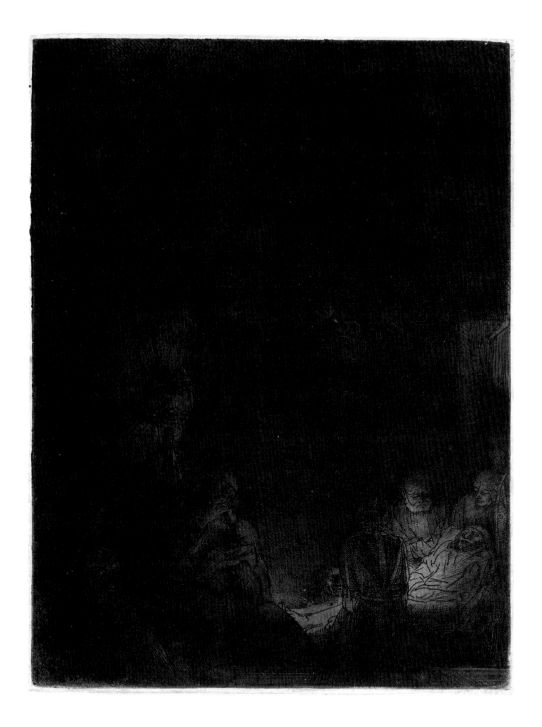

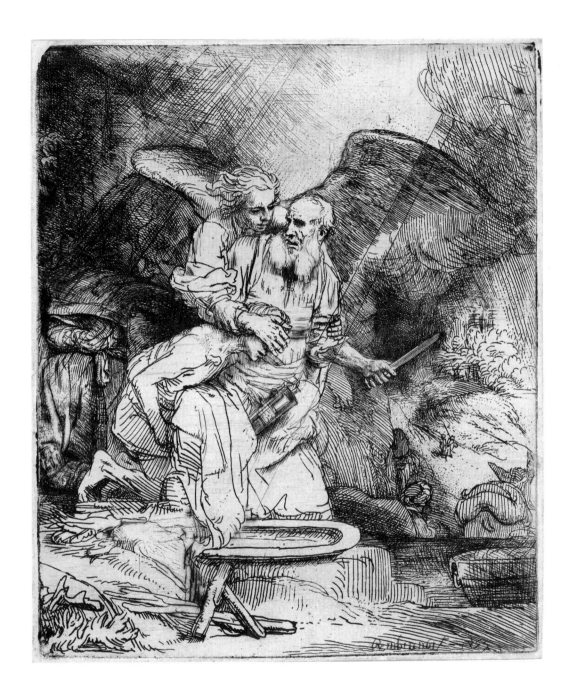

76 49
Abraham's sacrifice, 1655

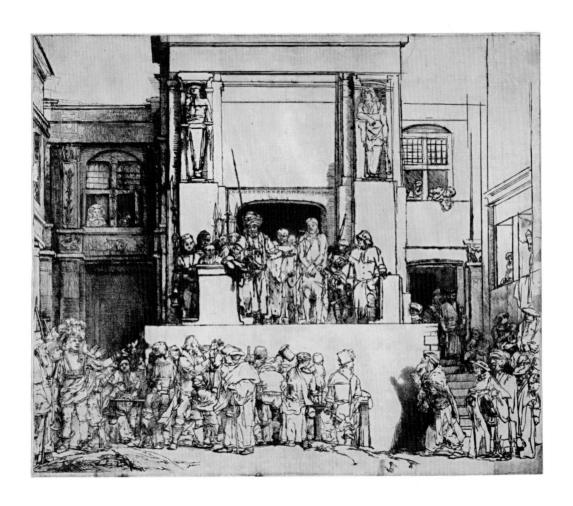

50
Christ presented to the people, 1655

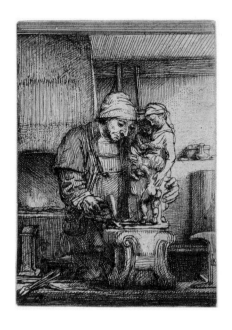

51
The goldsmith, 1655

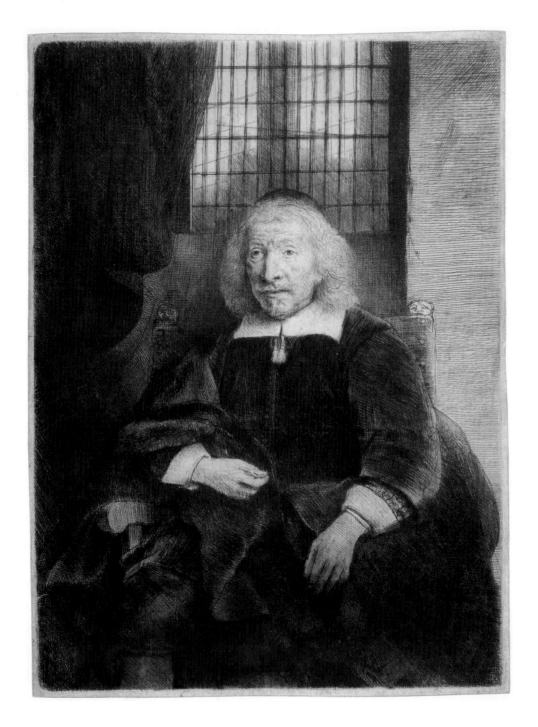

52
Thomas Jacobsz. Haringh, c.1655

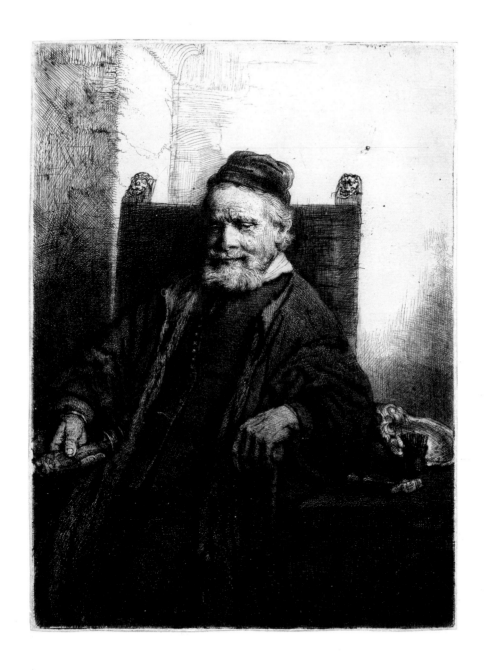

53 a–b
Jan Lutma, 1656
first state; second state, on Japanese paper

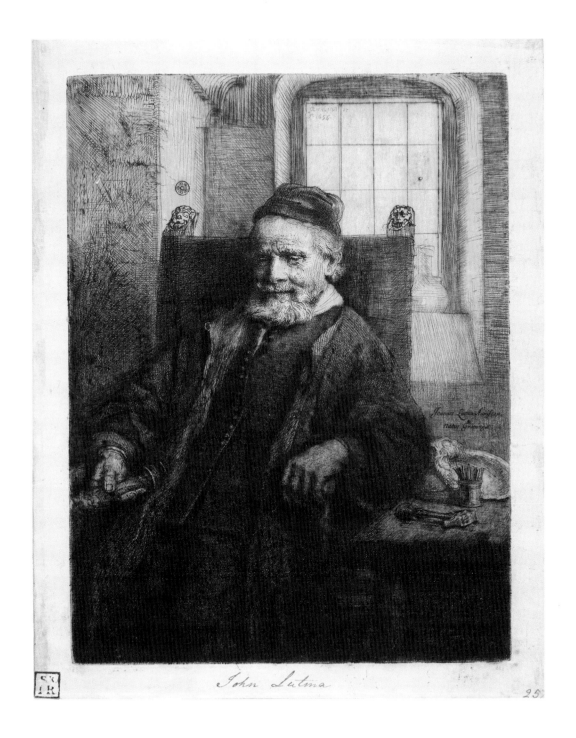

John Lutma

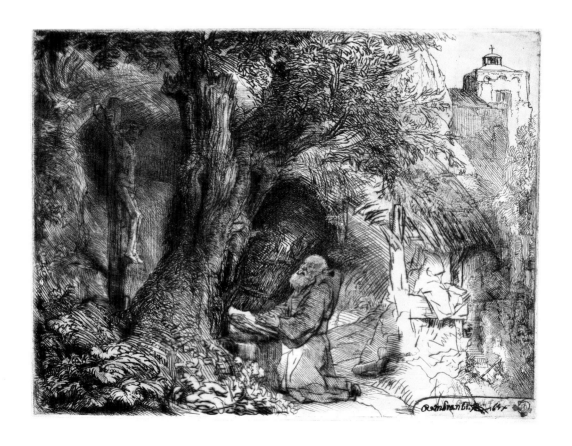

54
St Francis beneath a tree praying, 1657

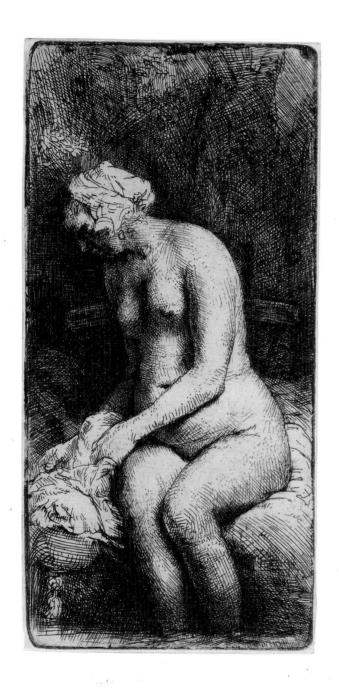

84 55
Woman bathing her feet in a brook, 1658

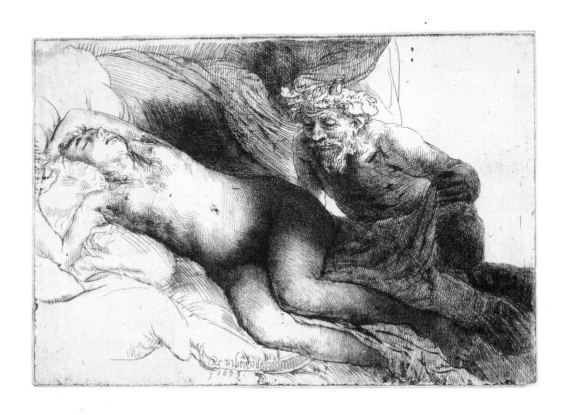

56
Jupiter and Antiope, 1659

Rembrandt's prints
some technical terms

Counterproof
The image is printed from another impression while the ink is still wet. A counterproof shows the image in the same direction as it appears on the original copper plate. This can be useful when contemplating changes to the plate.

Drypoint (and burr)
The artist draws directly on a copper plate with a sharp needle. The resulting scratchy lines have uneven ridges of metal along them, known as 'burr'. When printing, the ink clings to the burr, creating a smudged, velvety effect, which Rembrandt fully exploited. He often combined drypoint with etching.

Engraving
Lines are cut cleanly and directly into the copper using a special tool, a burin. Rembrandt primarily used the burin to deepen or reinforce lines that had already been etched.

Etching
A smooth copper plate is covered with an acid-resistant coating. The artist draws into this surface with a blunt needle, exposing the copper beneath. The plate is then immersed in acid: this bites into the exposed parts of the copper, creating the lines. The longer the acid bites, the deeper the lines. Variety can be produced by biting the plate more than once, covering some lines with an acid-resistant varnish before immersing the plate in acid again.

Once bitten, the plate is cleaned, removing the etching ground, and covered with a layer of ink. The ink enters the etched lines, while the smooth surface of the plate can be wiped clean. Impressions are then printed on paper using a special press.

Plate tone
Rembrandt was fond of 'plate tone': he sometimes deliberately left some ink on the flat surface of the plate, creating areas that print with a greyish or black tone.

State
Each time lines are added to a plate, and it is also printed, a new 'state' of the print is created. This allows us to follow the artist's progress. For example, the first states of cat. 8 and 15 show only the head of a figure, while later states might show the body as well. The adjustments in Rembrandt's etchings range from minor additions to the complete reworking of the whole plate. Sometimes a print is known in numerous different states (eg. four states of cat. 8 are shown here).

Watermark
Paper manufacturers often included a symbol in the moulds from which paper was made. These had to be replaced regularly, and the study of watermarks sometimes allows individual sheets of paper to be dated accurately.

chronology

1606	Born in Leiden, son of a mill-owner.	**1634**	Marries Saskia van Uylenburgh.	**1655**	Makes the print of *Christ presented to the people* (cat. 50).

1606 — Born in Leiden, son of a mill-owner.

1620 — After completing tuition at the Leiden Latin School, enrolled at Leiden University (which he probably never attended).

1621 — Begins three-year apprenticeship in Leiden to a minor painter, Jacob van Swanenburgh.

1624/25 — For around six months studies in the studio of Pieter Lastman, the leading painter in Amsterdam.

c.1625 — Sets up as an independent painter in Leiden. Works closely with Jan Lievens until 1631.

c.1626 — Makes first etchings (see cat.1).

1631 — Settles permanently in Amsterdam, initially working for the entrepreneur and artist, Hendrick Uylenburgh.

1632 — Paints the *Anatomy Lesson of Dr Tulp* (now in the Mauritshuis, The Hague).

1633–39 — Series of paintings of Christ's Passion executed for Prince Frederick Henry of Orange (now in the Alte Pinakothek, Munich).

1634 — Marries Saskia van Uylenburgh.

1639 — Buys his own large house in Amsterdam (now a museum, the Rembrandthuis). His financial situation is always dogged by the expense of the transaction.

1641 — Birth of his son, Titus van Rijn.

1642 — Death of Saskia. Paints the so-called *Night Watch* (now in the Rijksmuseum, Amsterdam).

1643 — Makes the etching *The three trees* (cat. 27).

1647 — Makes the etching *Jan Six* (cat. 33).

1648 — Approximate date of *Christ healing the sick: the hundred guilder print* (cat. 36).

By 1649 — Hendrickje Stoffels enters Rembrandt's household as a servant. She replaces Geertje Dircx (with whom he had formed a liaison following Saskia's death in 1643) in his affections.

1653 — Makes the print of *The three crosses* (cat. 46).

1654 — Birth of his daughter Cornelia by Henrickje Stoffels.

1655 — Makes the print of *Christ presented to the people* (cat. 50).

1656 — Voluntarily assigns his assets to his creditors via the courts. His assets, including his house and art collection, sold to pay them in 1656–58.

1661 — His painting of *The Conspiracy of Claudius Civilis* executed for the Town Hall of Amsterdam. Probably judged a failure, it is replaced by a work by one of his former pupils (a fragment of Rembrandt's picture survives in the Nationalmuseum, Stockholm).

1663 — Death of Hendrickje Stoffels.

1668 — Death of his son Titus van Rijn.

1669 — Rembrandt dies in Amsterdam.

catalogue

All measurements are in millimetres, height x width. Page references are to illustrations in this book.

All works are reproduced courtesy of the British Museum and are from the British Museum's collection.

Many of the works were acquired by the British Museum from the following four collections, which are referred to as follows:
Cracherode: bequeathed by Clayton Mordaunt Cracherode, 1799
Slade: bequeathed by Felix Slade, 1868
Malcolm: acquired with the collection of John Malcolm of Poltalloch, 1895
Salting: bequeathed by George Salting, 1910

For a fuller discussion of the prints, see Erik Hinterding, Ger Luijten, Martin Royalton-Kisch, *Rembrandt the Printmaker*, British Museum Press, London, 2000 (reprinted 2001), on which this catalogue section is largely based.

1 (p. 16)
The rest on the flight into Egypt, *c.*1626
Etching; 217 x 165
H.307, only state
1925-6-15-24

One of Rembrandt's first attempts at etching, a technique he had yet to master. The figures lack volume and meld into their surroundings. The style resembles that of early etchings by Jan Lievens who was Rembrandt's close associate during this period.

2 a–b (p. 17)
The artist's mother: head only, 1628
Etching; 63 x 64
H.2, second state
Cracherode 1973.U.737
H.2, second state
1843-6-7-219

For several of Rembrandt's early prints he used his elderly mother as his model. He produced a first state of the print showing only the face without the shawl. In the second state of the print, the copper plate was awkwardly cut immediately under the sitter's chin, suggesting that the artist may not have been satisfied with some aspect of the result. Yet this is among the earliest of his etchings to display the proficiency of drawing of which he was capable.

3 (p. 18)
Peter and John at the gate of the temple, *c.*1629
Etching; 221 x 169
H.5, only state, lines retouched in parts with brush and grey ink
1848-9-11-50

Saints Peter and John encountered a beggar at the gate of the temple of Jerusalem who had been lame since birth. Peter said that he could offer him neither silver nor gold but healed him in the name of Christ. This etching, the largest from Rembrandt's early years, is broad in style and displays a variety of technical flaws. This is a rare print, being one of just three recorded impressions from the copper plate.

4 a–b (p. 19)
Beggar seated on a bank, 1630
Etching; 116 x 70
H.11, only state
Cracherode 1973.U.742
H.11, only state
Cracherode 1983.U.2762

Two impressions are included here.
Rembrandt endowed the beggar with
facial features resembling his own. In
the same period he was also producing
character studies based on his own
image as he made faces in a mirror
and recorded the results on copper
plates. Here he may have based the
head on one such study, *Self-portrait,
open-mouthed* (cat. 5).

5 a–c (p. 20)
Self-portrait, open-mouthed, 1630
Etching; 83 x 72
H.31, first state
Cracherode 1973.U.767
H.31, second state
Cracherode 1973.U.768
H.31, third state
Purchased 1845-2-5-1

Rembrandt may have based the face
of the beggar in cat. 4 on this print.
He often studied his own face in the
mirror in order to capture realistic
expressions for use in his finished
prints and paintings.

6 (p. 21)
Self-portrait with beret, wide-eyed,
1630
Etching; 51 x 46
H.32, only state
Cracherode 1973.U.769

(see cat. 7)

7 (p. 21)
Self-portrait with curly hair, c.1630
Etching; 51 x 46
H.33, second state
Cracherode 1973.U.770

In 1678 Rembrandt's pupil Samuel van
Hoogstraeten recommended the use of
a mirror to study expressions, so that
the artist could be both 'presenter and
beholder' at the same time. Perhaps
he derived this advice from Rembrandt,
who here depicts himself with a vivid
expression of surprise (cat. 6), and with
a serious look and strong contrasts of
light (cat. 7).

8 a–b (p. 22)
Bald-headed man in profile; the artist's
father?, 1630
Etching; 118 x 97
H.23, preliminary state with additions
in brush and grey ink
Cracherode 1973.U.761
H.23, first state
1848-9-11-154

Rembrandt often used his father as
a model in his early etchings. Cat. 8a
is a unique impression of the print,
with only the father's head realised,
and the remainder drawn in by
Rembrandt as a sketch. Cat. 8b shows
that Rembrandt removed the circle
or halo around the figure's head.

8 c–d (p. 23)
Bald-headed man in profile; the artist's
father?, 1630
Etching; 118 x 97 and 69 x 58
H.23, second state
1855-4-14-272
H.23, third state
1843-6-7-174

In the second state, Rembrandt
followed the sketch indications he had
added on cat. 8a. Finally, in the third
state, he filled in the background and
cut the plate down considerably,
adding his signature in the lower right
corner with the date, 1630.

9 (p. 25)
Naked woman seated on a mound,
c.1631
Etching; 177 x 160
H.43, second state
1843-6-7-126

This etching is remarkable for its
unflinching realism. Yet it may depict
a goddess from mythology, or perhaps
one of Diana's retinue of nymphs.
Rembrandt was criticised in his
lifetime for failing to idealise figures
in such illustrations.

10 a–b (pp. 26–27)
Sheet of studies, c.1631–32
Etching; 101 x 114
H.90, first state
1848-9-11-187
H.90, second state
Cracherode 1973.U.814

This etching has the character of
an informal sketchbook page, and
Rembrandt rotated the plate three
times in order to find space for all
the motifs. The dominant self-portrait
may have been drawn first, and
deemed a failure. No substantial
edition was printed in Rembrandt's
lifetime. The watermark found in the
paper in the rare first state is only
otherwise known in a print of 1641,
suggesting that this etching may only
ever have been printed then, ten years
after it was made. The plate was later
put through the press in a second
state, but this was probably done after
Rembrandt's death.

11 (p. 29)
The raising of Lazarus: larger plate,
c.1632
Etching and engraving; 366 x 258
H.96, second state, touched with
graphite
1848-9-11-35

This highly-worked etching is related
to a painting by Rembrandt (now in the
Los Angeles County Museum of Art).
Rembrandt subsequently repainted the
panel, so that it no longer resembles
the print closely. Rembrandt's etching
went through seven states. The main
change he made was to the pose of
Lazarus's sister, Martha, in the lower
right corner. Rembrandt sketched the
change in graphite on this impression,
an addition that has been partly
erased.

12 a (p. 30)
The angel appearing to the shepherds,
1634
Etching, drypoint and engraving;
262 x 218
H.120, first state, with touches of
brownish wash
Cracherode 1973.U.850

This is Rembrandt's first etching of
a nocturnal scene. He achieved the
intense blackness by combining
etching, drypoint and engraving in a
painstaking technique. The confusion
that overwhelms the shepherds and
their flock at the sight of the angel who
brings the tidings of the birth of Christ
is rendered imaginatively, with a sense
of drama and humour. Several areas
were left unfinished in this, the rare,
first state, but the contours of the
figures were already loosely indicated.

12 b (p. 31)
The angel appearing to the shepherds,
1634
Etching, drypoint and engraving;
262 x 218
H.120, third state
1868-8-22-662

The plate was completed in the second
state, and in this, the third and last
state, Rembrandt added extra shading
to the branches of the dying tree and to
the foreground. This extra work, as is
now known from the watermarks in
the paper, was completed in 1634.

13 (p. 32)
Johannes van Vliet after Rembrandt
The descent from the cross (second
plate), 1633
Etching and engraving; 530 x 410
H.103, second state
1843-6-7-61

This ambitious print reproduces a
painting by Rembrandt made for
Frederik Hendrik, the Prince of Orange
(now in the Alte Pinakothek, in Munich).
Rembrandt employed Johannes van
Vliet to make the plate under his
supervision. *Christ before Pilate* (cat. 14)
was made in the same way, as a pair to
this print, in 1634–36, and a series of
such prints may have been planned.

14 (p. 33)
Johannes van Vliet after Rembrandt
Christ before Pilate: larger plate,
1635–36
Etching, drypoint and engraving;
549 x 447
H.143, third state
Cracherode 1973.U.938

This print, the work of Johannes van
Vliet, is a pair to cat. 13. It was based
on a detailed oil-sketch by Rembrandt
(now in the National Gallery in London).
Van Vliet found the oil-sketch difficult to
follow and the plate was only finished in
this, the third state. Rembrandt himself
also intervened directly on the plate:
for example, he added shade in the
background and gave the bald man near
the lower left corner a cap and more hair.

15 a (p. 34)
The great Jewish bride, 1635
Etching, drypoint and engraving;
219 x 168
H.127, second state
Cracherode 1973.U.868

Rembrandt's wife Saskia Uylenburgh
modelled for this print. Rembrandt
appears initially to have worked
directly from life, elaborating the
costume and background in later
states – the fifth state is cat. 15b.

15 b (p. 35)
The great Jewish bride, 1635
Etching, drypoint and engraving;
219 x 168
H.127, fifth state
Cracherode 1973.U.867

In this, the fifth state, the composition
is completed. Rembrandt probably
intended the image to represent the
Old Testament heroine, Esther, clad in
her 'royal apparel' and clasping the
royal decree to slay her people, the
Jews, before interceding on their
behalf with King Ahasuerus (otherwise
known as Xerxes I).

16 a–c (p. 36)
The pancake woman, 1635
Etching; 177 x 109
H.141, first state
1848-9-11-62
H.141, second state
Cracherode 1973.U.880
H.141, third state
1856-6-14-70

Rembrandt's etching has the
immediacy of a drawing from life, and
was probably based on a sketch. The
hunger-induced eagerness of the
young customers is almost tangible:
the child on the right gazes longingly
into the frying pan while the toddler in
the foreground holds its morsel away
from an importunate dog. In the rare
first state the figures are less worked
up than in the second and third states,
which were intended for the market.

17 (p. 37)
Adam and Eve, 1638
Etching; 162 x 116
H.159, first state, touched in black chalk
1852-12-11-42

Rembrandt stresses Adam and Eve's vulnerable humanity, wholly unlike the idealised figures that were usually portrayed by artists. The drawn retouches he made on the left of this impression were not followed up in the second state. The background contains Rembrandt's most sophisticated landscape to date, and includes an elephant as well as the devil, the latter modelled on a print by Albrecht Dürer (1471–1528).

18 (p. 38)
The death of the Virgin, 1639
Etching and drypoint; 409 x 315
H.161, second state
Cracherode 1973.U.899

Rembrandt departs from traditional representations of this scene, although the composition was partly inspired by a woodcut by Albrecht Dürer (see also cat. 17). The inclusion of figures other than the apostles occurs in a design by Pieter Bruegel (c.1525–69), but the depiction of the Virgin as a sick woman with a physician checking her pulse is Rembrandt's own invention.

19 (p. 39)
Jan Uytenbogaert, 'The Goldweigher', 1639
Etching and drypoint; 250 x 204
H.167, third state
Cracherode 1973.U.911

The sitter was responsible for collecting taxes, and Rembrandt portrayed him at work. This gives the print the character of a genre scene, which is why it was later dubbed 'The Goldweigher'. The sitter's face was left blank in the first state, and Rembrandt needed another session with him for the likeness.

20 a–b (p. 41)
Self-portrait leaning on a stone sill, 1639
Etching; 205 x 164
H.168, second state
Salting 1910-2-12-356
H.168, second state
Malcolm 1895-9-15-411

Rembrandt depicts himself here in Renaissance attire, taking inspiration from paintings by Raphael and Titian, painters whom he greatly admired. He probably saw himself as a torch-bearer for the extraordinary tradition of European art that they, and others, had initiated (Rembrandt also particularly admired Mantegna, Leonardo da Vinci, Albrecht Dürer and Lucas van Leyden – the latter came from Rembrandt's native town, Leiden).

21 (p. 42)
The artist drawing from the model, c.1639
Etching, drypoint and engraving; 232 x 184
H.231, second state
1843-6-7-121

This etching was formerly titled 'Pygmalion', after the legend of the Greek sculptor of that name who fell in love with an ivory statue he had fashioned, brought to life by Venus at his request. Rembrandt may have intended the print to emphasise the importance of drawing from life. The design was never completed beyond the stage seen here (the second state) although he made a drawing to plan its completion.

22 a–b (p. 43)
Sleeping dog, c.1640
Etching and drypoint; 64 x 105 and 47 x 90
H.174, first state
1842-8-6-144
H.174, second state
Cracherode 1973.U.919

Only a few impressions are known of the first state of this delicate study from life, which leaves much of the plate empty. The plate was then cut down. In the upper right corner and around the dog, Rembrandt used drypoint to deepen the shadows.

23 (p. 44)
View of Amsterdam, c.1641
Etching; 112 x 153
H.176, only state
Slade 1868-8-22-676

The city's skyline is depicted from the north-east, though reversed through printing. Although the topography is not entirely accurate, Rembrandt may have drawn the image on a prepared plate on the spot, seated by the Kadijk. Despite the high quality of this impression, the watermark in the paper (showing a 'Strasbourg lily with initials LC') suggests that it was not printed until around 1645.

24 (p. 45)
The windmill, 1641
Etching; 145 x 208
H.179, only state
Slade 1868-8-22-687

Rembrandt here drew in great detail the 'Little Stinkmill' that stood on a rampart in Amsterdam, not far from where the Rijksmuseum stands today. Its name was derived from its function, using cod-liver oil to soften tanned leather. A grey tone is noticeable in the sky, and small cracks appear in various places, the result of the way in which the etching ground was applied.

25 (p. 46)
The triumph of Mordecai, c.1641
Etching and drypoint; 174 x 215
H.172, only state
Cracherode 1973.U.915

Rembrandt depicted several episodes
from the Book of Esther. Here
Mordecai (mounted) and Haman
(standing in the foreground) are
depicted before they comprehend the
change in their fortunes resulting from
the former's elevation and the latter's
condemnation by King Ahasuerus
(Xerxes I). The king is shown with
Esther on the balcony on the right.
Rembrandt's virtuosity is clear from
the range of his touch, from the wispy
lines on the right to the pitch black at
the top left, achieved with the addition
of drypoint.

26 (p. 47)
The sow, 1643
Etching and drypoint; 145 x 184
H.204, first state
1843-6-7-105

A sow is prepared for slaughter, an
oblique reference to the brevity of life.
In the background, a butcher prepares
the tools of his trade: an axe and a
curved yoke, or a cambrel on which
to hang the carcass. Children approach
to watch the spectacle, including a boy
who squeezes a pig's bladder to make
the sound of breaking wind.

27 (p. 48)
The three trees, 1643
Etching, drypoint and burin; 213 x 279
H.205, only state
Slade 1868-8-22-678

This is Rembrandt's most famous and
elaborate landscape etching. It is
marked by his attention to detail, from
the distant windmills and towers to the
figure seated up on the dyke to the
right. The sky, often blank in
Rembrandt's prints, here sets the
mood, turbulent with sweeping clouds
receding after a downpour. The power
of nature predominates and the figures
– from the fisherman on the left to the
pair of lovers obscured in the bushes
at the lower right – seem insignificant.

28 a–b (p. 49)
Six's bridge, 1645
Etching; 129 x 224
H.209, first state
1847-11-20-3
H.209, second state
1847-11-20-4

Compared with the highly finished
and pictorial Three trees (cat. 27),
Six's bridge appears like a rapid sketch
from nature. An anecdote related in
the eighteenth century claims that
Jan Six wagered Rembrandt to
complete an etching in the time it
took a servant to fetch a pot of mustard
from a nearby village, whereupon the
artist produced this plate. The print
does not, however, depict Six's own
estate, but an area a little north of
Ouderkerk, not far from Amsterdam.
The difference between the two states
shown is minimal: the nearer man's
hat is shaded in the second.

29 (p. 50)
The monk in the cornfield, c.1646
Etching and drypoint; 47 x 66
H.224, only state
1848-9-11-95

(see cat. 30)

30 (p. 51)
The French bed, 1646
Etching, drypoint and burin; 125 x 224
H.223, third state
1848-9-11-94

Rembrandt owned an album of prints
by Italian Renaissance artists depicting
the fornication of mythological figures.
These etchings are Rembrandt's chief
contribution to the erotic tradition, in
which he replaced the gymnastics of
the Roman school with more tender
and realistic representations. The
monk in the cornfield is based on an
engraving by Heinrich Aldegrever
(1502–55/61). The jug on the left
identifies the woman as a milkmaid,
a profession that had a reputation
in the erotic sphere. The French bed
has sometimes been construed as
an allusion to the Prodigal Son in the
brothel. The woman has two left arms,
and this has never been explained.

31 (p. 52)
Ephraïm Bueno, physician, 1647
Etching, drypoint and burin; 241 x 177
H.226, second state
1982.U.2758

The sitter was a Jewish physician
and a respected translator and poet.
Rembrandt portrayed him in a dignified
attitude at the foot of a staircase,
basing the print on an oil-sketch he
had made.

32 (p. 53)

Jan Asselijn, painter, c.1647
Etching, drypoint and burin; 216 x 170
H.227, first state, on Japanese paper
Cracherode 1973.U.985

The painter Jan Asselijn (c.1614–52) was nicknamed 'Little Crab' (Crabbetje) because of the deformation of his left hand, which Rembrandt has discreetly disguised. The portrait – Rembrandt's first of a fellow-artist – was made shortly after Asselijn, a landscape painter, returned to Holland from Italy. In printing the image, Rembrandt experimented with different papers. The Japanese paper of this impression tones down the contrasts, an effect enhanced by surface tone. Rembrandt subsequently removed the easel and painting in a later state of the print.

33 (p. 54)

Jan Six, 1647
Etching, drypoint and burin; 244 x 191
H.228, fourth state
Cracherode 1973.U.987

The sitter, Rembrandt's friend and patron Jan Six (1618–1700), probably commissioned this etching, one of Rembrandt's most highly-finished prints. Even the peg holding up the window is carefully described. The print is a remarkably informal portrait for its time, showing Six, his shirt unbuttoned, leaning casually against the window-sill. It was, however, never published in a substantial edition.

34 (p. 55)

Self-portrait, etching at a window, 1648
Etching, drypoint and burin; 160 x 130
H.229, second state, on Japanese paper
Salting 1910-2-12-357

This informal self-portrait shows Rembrandt wearing a simple artist's smock, holding an etching-needle as he peers into the mirror. The copper plate is raised on two books and lies at an angle on a few sheets of paper beneath it. In later states Rembrandt added a landscape view outside the window.

35 (p. 56)

Beggars receiving alms at the door, 1648
Etching, drypoint and burin; 166 x 129
H.233, first state
Slade 1868-8-22-673

Rembrandt produced a wealth of informal sketches of beggars, but this is his most elaborate image of them. The utmost care has been lavished on the characterisations, including the old man wearing a house-cap who has fished out a coin, and the boy with his left sock around his ankles. The composition has a geometrical simplicity that becomes increasingly characteristic of Rembrandt's later work, an effect here enhanced by the architecture, right down to the gutter in the foreground.

36 (p. 57)

Christ healing the sick: the hundred guilder print, c.1648
Etching, drypoint and burin; 278 x 388
H.236, second state
Salting 1910-2-12-383

This famous etching was already in such demand within five years of its creation that it was changing hands for a hundred guilders – an astonishing price that earned it its nickname. Rembrandt's masterly illumination of this complex scene rivals his painted masterpiece, the so-called *Night Watch* (now in the Rijksmuseum in Amsterdam). The print represents Christ healing the sick and encouraging the approach of children, while the Pharisees on the left debate with him. Rembrandt's style here ranges from sketchiness to elaborate detail.

37 (p. 59)

The shell (Conus marmoreus), 1650
Etching, drypoint and burin;
97 x 132
H.248, second state
Slade 1868-8-22-672

A specimen of the marbled shell may have been among the 'large quantity of conches and marine inhabitants' recorded in the 1656 inventory of Rembrandt's possessions. In the rare first state of the print, the background is left white. Rembrandt had applied shading to sections of the shell that are in reality pure white, and doubtless the dark background of this, the second state, was intended to counter the optical effect of having done this. The shell is native to South East Africa, Polynesia and Hawaii, and is shown life-size.

38 a–b (pp. 60–61)

Landscape with three gabled cottages, 1650
Etching and drypoint; 161 x 202
H.246, third state
Cracherode 1973.U.1033
H.246, counterproof of third state
1848-9-11-107

This print is based on a drawing that Rembrandt made on the Schinkelweg near (now in) Amsterdam. His intention was not to produce an accurate view, and in any case it prints in reverse. The rich darks created by the drypoint burr are especially notable in the foliage of the tree in the foreground. The counterproof shows the lines as they were drawn on Rembrandt's copper plate. Like the impression of the third state exhibited alongside, it was printed in around 1652, when Rembrandt may have contemplated making further alterations, but none was carried out.

39 (p.62)

Landscape with trees, farm and buildings and a tower, c.1651
Etching and drypoint; 123 x 319
H.244, fourth state
Salting 1910-2-12-398

The house with the tower enables us to identify the location, to the south west of Amsterdam on the road to Amstelveen. The sun-drenched landscape is atmospheric, with long shadows suggestive of late afternoon. The house belonged to Jan Uytenbogaert, the tax inspector whom Rembrandt portrayed in *The Goldweigher* in 1639 (cat. 19).

40 (p. 63)

The goldweigher's field, 1651
Etching and drypoint; 120 x 319
H.249, only state, on Japanese paper
Slade 1868-8-22-688

The title acquired by this print in the eighteenth century was probably a mistake, and should actually refer to cat. 39. It is a view of Haarlem seen from the dunes: the great church of St Bavo stands out on the horizon. In the foreground lies the Saxenburg estate, which belonged to Christoffel Thijsz., to whom Rembrandt owed money. Rembrandt must have made the etched lines before adding those in drypoint which, in this early impression on Japanese paper, print with rich burr.

41 (p. 64)

Clement de Jonghe, 1651
Etching, drypoint and burin; 207 x 161
H.251, first state
Cracherode 1973.U.1041

Clement de Jonghe (1624/25–77) was an Amsterdam print and map dealer, who came to own 74 copper plates by Rembrandt. The identification has been disputed, not least on the grounds that he looks older than 26 in the print; but a dated inscription of 1668 on the back of one impression already carries this identification.

42 (p. 65)

Christ preaching ('la petite tombe'), c.1652
Etching and drypoint; 155 x 207
H.256, only state
Cracherode 1973.U.1060

Rembrandt was partly inspired for this balanced composition by a print showing Raphael's fresco of Parnassus in the Vatican. An informal note is struck by the child doodling on the ground and the pair of feet protruding in the lower right corner.

43 (p. 66)

A scholar in his study ('Faust'), c.1652
Etching, drypoint and burin; 210 x 160
H.260, first state, on Japanese paper
Cracherode 1982.U.2752

The traditional title of the print, *Faust*, is not certainly accurate. The figure may represent an alchemist, which is how the plate was first described, or else Faust himself, or even Faustinus Socinus, the founder of the Socinian sect. Especially puzzling is the inscription in the window, which contains the letters INRI that were placed above Christ's head at his Crucifixion. A mysterious pair of hands holds and points to a mirror. A recent suggestion is that the image illustrates St Paul's first letter to the Corinthians, in which he likens the limitations of human as opposed to divine knowledge (symbolised by the incomprehensible inscription) to looking in a mirror at obscure reflections – 'through a glass darkly'.

44 (p. 67)

A clump of trees with a vista, 1652
Drypoint; 156 x 211
H.263, second state
Slade 1868-8-22-681

This print may have been started out of doors, and shows a scene that reappears in other works by Rembrandt and artists in his circle. The plate is executed entirely in drypoint, and the smudged quality of drypoint lines has been used to full advantage.

45 (p. 69)

St Jerome reading in an Italian landscape, c.1653
Etching, drypoint and burin; 259 x 210
H.267, second state
Slade 1868-8-22-669

Rembrandt gave particular attention to the Italianate landscape background, which he derived from works by Venetian printmakers from Titian's circle. St Jerome (seen with the lion which, according to legend, never left the saint's side after he removed a thorn from its foot) is indicated only in outline. Rembrandt never fully completed the print, although he shows the foreground in shadow in a preparatory drawing.

46 a–b (pp. 70–71)
The three crosses, 1653
Drypoint and burin; 385 x 450
H.270, third state
Cracherode 1973.U.941
H.270, fourth state
Cracherode 1973.U.942

Rembrandt conceives of the scene of Christ's crucifixion with a proto-cinematic eye. A sense of confusion reigns among the figures, all set against ethereal contrasts of light. The image has the impact of a painting, and achieves rich contrasts using drypoint throughout, which prints with velvety blackness.

The fourth state impression reveals that after the plate became worn, Rembrandt reworked it completely. He burnished away numerous figures, added others with rough lines in drypoint, and created more curtains of darkness across the plate. The abundant, fresh lines concealed the first version, while creating a greater sense of drama.

The fourth state was long dated to around 1660, but recent research into the papers Rembrandt used reveals that the comprehensive reworking must have taken place soon after the third state. The figure of a horseman in profile is based on a medal designed by the fifteenth-century Italian artist Antonio Pisanello, which Rembrandt may have had in his own collection.

47 (p. 73)
The descent from the cross by torchlight, 1654
Etching and drypoint; 210 x 161
H.280, only state
Cracherode 1973.U.1084

Rembrandt emphasises the drama of the nocturnal scene by using just one light source, the torch held aloft near Christ's dead body (still attached to the cross by a nail through the foot). An extraordinary effect of poignancy is given by the raised arm of the figure below Christ's head, while the faces on the extreme left, including the man holding a hammer, are fully characterised.

48 a–b (pp. 74–75)
The entombment, c.1654
Etching; 211 x 161
H.281, first state, on Japanese paper
Cracherode 1973.U.1086
H.281, second state, on Japanese paper
1842-8-6-140

Rembrandt took his experiments with surface tone, inking methods and different papers to extremes in this print. This first state is cleanly printed on pale Japanese paper, and contrasts entirely with the second state shown alongside. Although Rembrandt, in the second state, added a dense web of shading to the background of the print, this is entirely obscured by surface tone (a film of ink left on the surface of the plate before it was printed). Only in and around the dead body of Christ has the plate been wiped to reveal the main figures, who emerge like spectres from the pitch darkness.

49 (p. 76)
Abraham's sacrifice, 1655
Etching and drypoint; 156 x 131
H.283, only state
Slade 1868-8-22-659

This print depicts the highly-charged moment when the hand of Abraham, poised to sacrifice his son Isaac to fulfil God's command, is stayed by an angel. Rembrandt's characterisation of the elderly prophet Abraham's state of mind is profound.

50 (p. 77)
Christ presented to the people, 1655
Drypoint; 383 x 455
H.271, third state, on Japanese paper
Cracherode 1973.U.932

The print depicts the scene when the captive Christ was shown to the people of Jerusalem, who called for his death by crucifixion. The man in the turban is Pontius Pilate, the Roman governor (or procurator) who reluctantly acceded to their demands. Like *The three crosses* (cat. 46), this print is executed wholly in drypoint. Rembrandt may have regarded these two monumental sheets as a pair.

51 (p. 78)
The goldsmith, 1655
Etching and drypoint; 77 x 56
H.285, first state
1843-6-7-81

The purpose of this small plate which, in its devotion to detail, seems almost to imitate the skills of a goldsmith, is unknown. Some earlier printmakers, including Albrecht Altdorfer (c.1480–1538) and Dirck Vellert (c.1480–1547), had also created masterpieces on this small scale. Rembrandt's figure seems to be putting the finishing touches to a statuette personifying Charity.

52 (p. 79)
Thomas Jacobsz. Haringh, c.1655
Drypoint and burin; 195 x 149
H.287, second state
Salting 1910-2-12-402

Thomas Haringh was about 70 years old when Rembrandt made this portrait. He was a connoisseur of prints, and an auctioneer – he was to co-ordinate the sales of Rembrandt's possessions that took place between 1656 and 1658. Rembrandt also etched Haringh's more youthful cousin, and the prints have become known as the 'Old Haringh' and the 'Young Haringh'. The deep velvety blacks made possible by the drypoint technique soon wore out, and impressions from this plate are rare.

53 a–b (pp. 80–81)
Jan Lutma, 1656
Etching and drypoint; 196 x 150
H.290, first state
Salting 1910-2-12-403
H.290, second state, on Japanese
paper
Slade 1868-8-22-696

The hammer, silver dish and pot
containing punches betray the
profession of this well-known
silversmith, Jan Lutma (c.1584–1669).
Late in life his sight began to fail
him, which may explain his somewhat
vacant, half-open eyes. Rembrandt
revised the composition and, in the
second state here shown, added a
window with a glass bottle in front
of it. Lutma himself probably owned
the plate and may have requested
the changes. This fine impression of
the second state on Japanese paper
was owned by Sir Joshua Reynolds
(1723–92): his collector's mark, which
was applied by his executors, appears
in the lower left corner. Another
collector has written 'John Lutma'
below the image.

54 (p. 83)
St Francis beneath a tree praying, 1657
Drypoint and etching; 180 x 244
H.292, second state
Cracherode 1973.U.1119

St Francis is seen praying before a
crucifix. His companion, Brother Leo,
is sketched in outline on the right in
a style reminiscent of the figure of
St Jerome in cat. 45. Rembrandt's
working method in this late print is
extraordinarily painterly. He often
started by etching a plate, and adding
drypoint later, but in this case he
worked the other way around. The
first state was entirely in drypoint
and in this, the second state, he added
in etching some extra foliage and
the trees and tower on the right. The
drypoint lines produce especially rich
and contrasting effects.

55 (p. 84)
Woman bathing her feet in a brook,
1658
Etching; 160 x 80
H.298, only state
Salting 1910-2-12-366, on Japanese
paper

This etching probably depicts a model
posing in the studio. Rembrandt then
added the vaguely outlined tree trunk
and leaves in the background and the
suggestion that the woman is dangling
her feet in the water. In approaching
the female nude as a subject
Rembrandt's approach is usually
restrained rather than erotic, depicting
the figure in an unselfconscious pose
and concentrating on the effects of
light. The pose of the nude in cat. 56
is more sexually charged, as is
demanded by the subject-matter.

56 (p. 85)
Jupiter and Antiope, 1659
Etching, drypoint and burin; 138 x 205
H.302, first state
Salting 1910-2-12-368

This peerless etching depicts the nude
Antiope asleep on a mound of pillows,
ogled by Jupiter in the guise of a satyr.
Antiope's sleeping state has been
rendered utterly convincingly – mouth
open, the left arm totally relaxed –
and one is tempted to believe that
Rembrandt drew directly from a
snoring model. He based the
composition on an etching made
in 1592 by the Italian artist Annibale
Carracci which, however, includes
the figure of Cupid and a landscape
background. Typically, Rembrandt
restricts the iconography to its
essential elements.